REMARKABLE
Women of
STOCKTON

Remarkable Women of STOCKTON

MARY JO GOHLKE

Charleston · London

THE
History
PRESS

Published by The History Press
Charleston, SC 29403
www.historypress.net

Copyright © 2014 by Mary Jo Gohlke
All rights reserved

Front cover: Stockton's remarkable women include, *from top, left to right*: Maxine Hong Kingston. *Courtesy of the Bank of Stockton Archives*; Tillie Lewis. *Courtesy of the Haggin Museum*; Flora Mata. *Courtesy of the Mata family*; *center*: Harriet Chalmers Adams. *Courtesy of the San Joaquin County Historical Society & Museum*; *bottom*: Elizabeth Humbargar. *Courtesy of Jim Veraga, San Joaquin Delta College*; Inez Budd. *Courtesy of the Haggin Museum*.
Back cover: Where Stockton began: Weber Point and the Stockton Channel were the entrance to the Southern Mines. *Courtesy of the San Joaquin County Historical Society & Museum*. *Inset*: Lottie Ruggles. *Courtesy of Trudy Kurey*.

First published 2014

Manufactured in the United States

ISBN 978.1.62619.415.1

Library of Congress CIP data applied for.

Contents

Contents

Preface

The women who arrived in Stockton, California, soon after the gold rush did not plan to pan for gold. This was almost entirely a male occupation, and more than 90 percent of those who lived in the foothills of the Southern Mines, which the little river town of Stockton supplied, were men up until 1853. Those few women arriving by ship in San Francisco, or overland, were brought out by husbands or bridegrooms-to-be who had made some sort of a financial start.

It became evident that in Stockton, more money was to be made by business—supplying the gold diggers—than by digging for gold. Austin Sperry found "white gold" when he opened a flour mill in the early 1850s. By the time of his death three decades later, he had amassed a fortune, as did his cousin, S.W. Sperry, whose daughters married very well.

Likewise James Gillis, one of the first to trek across the Isthmus of Panama, parlayed a soda business into agricultural and steamboat successes. C. Lincoln Ruggles arrived as a newsman in town and saw his newspaper flourish. Inez Budd's family came from Connecticut, and her husband's relatives moved at the same time from Wisconsin to fill law vacancies in town.

The city's founder, Charles Weber, brought one of the first Anglo women to enter the state to little Tuleberg when he married Helen Murphy. Their only daughter, Julia, was born soon after Tuleburg became Stockton.

Once a little tent city, the area named after Commodore Robert F. Stockton made a success of itself after the rush for gold abated. Shanties evolved into sturdy wooden structures and then those of brick. By 1854,

Stockton was the fourth-largest city in California. Streets were graveled, and the railroad arrived. Manufacturing and industry were expanding, and prosperous merchants were building fashionable homes in the Magnolia District.

Stockton became more and more a city of successful people, and the women of the area developed their own community roles through business, education and the feminist pursuit of voting rights. Many skipped through the limited and traditional women's sphere and entered a new intellectual land. Gradually, in the less tradition-bound West, opportunities arose for women, and they were eager to take them. They ran steamship lines, explored the world and started manufacturing concerns.

As one century was left behind, women sailed ahead—and there were many "firsts." First to lead a mental facility, first to get a pharmacy degree, first to sit on the city council, first to integrate teacher ranks in Stockton schools. They wrote, they sat on boards, they managed farms, they ran for mayor, they fought racism and complacency and one even won the Presidential Medal of Freedom. They are all Stockton women. Some were brought here by their husbands or families; many others decided on their own that opportunities could be best realized on Stockton's peaty soil.

The twenty-two women chosen for these twenty chapters are all remarkable in a variety of ways. The Sperry sisters took on society during its golden age and, through marrying millions, were able to give much of their fortunes away. One hundred years later, Beverly Fitch McCarthy was leading feminist causes and marching with the Farm Workers—which Stockton's Dolores Huerta founded with Cesar Chavez. Elizabeth Humbargar was galvanized with the injustice of throwing Japanese into internment camps. Dawn Mabalon threw herself into saving what she could of Little Manila and writing about its cultural importance.

These are Stockton's community leaders. Some names, when spoken, cause a furrowed brow and the exclamation, "Wasn't she the one who…" Yes. She probably was.

Acknowledgements

My primary supporter in this project, as well as so many others in our forty years together, is my husband, Richard A. Gohlke, a tremendous editor but an even more precious soundboard and one who says, "Oh, you can do that!" Coming a close second (as a group) are my children, Sally Noma and her husband, Jason Noma, and my son, U.S. Marine major Daniel Gohlke and his Diana. Right up there with all of them is a lifelong (it seems) friend, Suzanne Sutterfield, whose quiet encouragement calmed many a nervous evening.

This book on remarkable women comes out of a discovery made through my membership with the Philomathean Club of Stockton, which in 2013 celebrated its 120th year in the Stockton community. My good friend Beverly Blixt and I were wondering about "those ugly old paintings" some of the women talked about. We looked in the cramped clubhouse library and saw them at the back of the room, covered in sheets. They went to auction and enriched our coffers by nearly $100,000.

Right about this time, local historian and author Dr. Alice van Ommeren asked me to research the club, as she wished to nominate the building, now over one hundred years old, for the National Register of Historic Places. It was accepted, and she graciously included my name on the nomination. Then she told me, "Now you can do a PowerPoint on the club. Or even write a book."

This is the book that has resulted; the club's history will have to wait a bit. My thanks to my editor at The History Press, Aubrie Koenig, gentle and encouraging every step of the way.

Some people go beyond kindness into some sort of red carpet treatment when you deal with them. William Maxwell was a treasure to work with at the Bank of Stockton Archives. Ron Chapman and Bradley Steele of the Stockton Police Archives have been most encouraging with research and photographs.

I have always been hesitant, for some reason, to approach institutions hat in hand. However, whenever I have come to our remarkable Haggin Museum, the curator, Tod Ruhstaller, has been thorough and immensely helpful. And out at the San Joaquin County Historical Museum in Lodi, Leigh Johnsen, the archivist/librarian, is similarly approachable. The people at Holt-Atherton Special Collections at the University of the Pacific have seen too much of me. Michael Wurtz, archivist, is joined by Trish Richards, Special Collections assistant.

Others giving particular help were the HOLT CAT Company of Texas, in particular Howard Hicks of its public relations department; B.D. Holt, Nick Holt and Catherine Holt, who offered their time for interviews; and Nancy Johnson Sicotte, who shared Anna Brown Holt's lineage and photos. Trudy Kurey gave me much direction and many photos relating to Lottie Ruggles, and Fredrick Husse was invaluable, providing so much useful material. Another rare photo, much encouragement and volumes of family lore came my way from my beloved late friend Alan "Sandy" Smith and his wife, Isolee. Janie Reddish has also been of help, and the encouragement of the Philomathean Club has been much appreciated.

Nothing is more difficult than digging up photos of the long-dead. Thank-yous go to Susan E. Snyder, head of Public Services for the Bancroft Library, University of California–Berkeley, and Christina Moretta of the San Francisco History Center, San Francisco Public Library. And every time I went into Kinko's for a photo scan, I promised them a spot on this page. Also of assistance were Jim Veraga of the Delta College Public Information Office and Steven Sue of the Stockton Branch, Japanese American Citizens League.

Also enriching my knowledge was the Stockton–San Joaquin Public Library System, where I was a librarian for eight years. All the staff are precious to me. Watching the strange books arriving for me, and wondering what it all meant, were Christine Lum and Fatima Domingo at the Weston Ranch Branch, my own little library now.

Chapter 1

The Sperry Sisters

Rich and Famous in the Golden Age

In Stockton of the 1870s, two little girls were growing up unaware that they would soon be rich and socially prominent for the rest of their lives, thanks to the Central Valley's bountiful wheat crop. They followed a nationwide trend of advantageous marriages of the *nouveau riche* to one another and, on the strength of their father's bank accounts, into society's highest ranks. One girl grew up to catch a Crocker and helped the younger sister grab a Polish prince.

The great wealth that manufacturing, agriculture, banking and other pursuits produced in the late 1800s translated into personal fortunes that expressed themselves along similar lines in cities large and small across the nation: ostentatious homes and upwardly mobile lifestyles. The great riches of the East Coast elite resulted in sprawling Newport mansions and a ferocious "society" structure in New York City that admitted only four hundred—the exact number that could fit in one society matron's ballroom.

From out of the West arose men and women without formal pedigrees whose fortunes had been newly acquired through industry and commerce—and yet they could not enter the drawing rooms of the rich New York families with their inherited millions, who descended from the city's first founders. Molly Brown of Colorado was one such; in San Francisco, a bevy of new rich found East Coast doors firmly shut against them. Indeed, many a wealthy Californian erected his domicile larger than life, and his cultural pursuits—a society hopeful *must* be culturally inclined—became a race "as headlong and haphazard as [the] rush to gold."

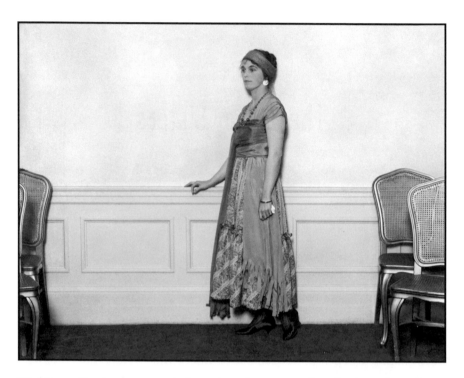

Ethel Sperry Crocker was a grande dame whose fortune came from Stockton wheat. *Courtesy of the Bancroft Library, University of California–Berkeley.*

San Francisco's settlers, some fabulously wealthy, immediately set about reinventing themselves into an "upper crust" that, even if ignored by New York, still by the turn of the century was a formidable social structure. "An invitation to Ned Greenway's cotillion might mark the capstone to a social career in San Francisco," explains Stephen Birmingham, "but it meant nothing to Mrs. Astor, whose doors remained closed."

The rich built memorials and mansions; Collis Huntington, for example, one of railroad's "Big Four," had three homes in California, one in New York and a getaway in the Adirondacks and then built a massive home in New York City and, as a finality, erected his own massive mausoleum.

Society, even in New York, was increasingly fed up with Mrs. Astor and her four hundred, and by the middle of the 1890s, a surprise route around the society bulwark was being created as new wealth took to marrying internationally—or marrying a foreign title, usually an English one. The second-generation new rich of many states began exploring this angle,

inspired perhaps by Jennie Jerome, Winston Churchill's mother, who married Lord Randolph Churchill in 1874.

Nine American heiresses married English peers in 1895, a high-water mark for what was to become a phenomenon in which more than one hundred young ladies bypassed local society for even greater prestige in the Old World—in most cases financing the lifestyle and restoring many a dour castle with their fathers' money.

San Francisco was the "second leading supplier" of the "dollars for titles" brigade. First off the mark was Flora Sharon, who in 1880 married Sir Thomas George Fermor-Hesketh, seventh baronet. Her father, William Sharon of San Francisco, was the Bank of California's Comstock Lode representative and a Nevada senator. He bequeathed over $5 million to his daughter on her marriage.

Stepping into the midst of the society gaiety were the lovely Sperry sisters of Stockton. Their father, Simon Willard "S.W." Sperry, was called in by a cousin to help run his flour mill. Austin Sperry fitted up a building at the corner of Main and Commerce Streets in 1852. He began with Napa and Martinez wheat, but soon the San Joaquin County crops came in and, with them, an increase in production. At one point, the firm was the second-largest flour producer in the state. Austin offered a partnership to S.W., who accepted and brought his wife, Caroline, and family from New York to the West Coast. By the 1870 census they were living in Stockton; for years, they resided on North Street (now Harding Way). Ethel was eight at the time; her little sister Elizabeth was born in 1872.

The mill continued to expand and thrive even after Austin's death in 1881 and a devastating fire two years later. By 1886, when Ethel was married, the Sperry family had become wealthy—and Ethel's riches were to flourish with her choice of husband, William H. Crocker, originally of Sacramento and now a San Francisco banker. His father, Charles, was one of the founders of the Central Pacific Railroad. He and his partners—Leland Stanford, Collis Huntington and Mark Hopkins—were dubbed the "Big Four." The younger Crocker became president of Crocker National Bank in 1893.

The nuptials between these two prominent families were greatly anticipated, and a large church wedding was planned. But S.W. died in September 1886, and in respect, the October 6 wedding was a small one held in the Sperry home on North Street. They immediately set out for the East Coast and a lavish honeymoon in Europe, returning to live in San Francisco in the Charles Crocker mansion on Nob Hill. After the senior

Crocker's death, they moved from their private wing to a Queen Anne–style home next door, completed in 1889.

Finally, the mourning periods for the various family deaths ended, and the Crockers began an avid social life, opening their mansion to dancer Isadora Duncan and actress Sarah Bernhardt. One of their guests was Prince Andre Poniatowski, grandson of the last king of Poland. His father served under Emperor Napoleon III of France. He was fresh from a failed romance with Maud Burke, who became Lady Cunard on her marriage in 1895 to Sir Bache Cunard. Delighted to make the acquaintance of Elizabeth "Beth" Sperry, now twenty-two, Poniatowski soon proposed, and another California heiress had married into European royalty.

They wed in two ceremonies in Paris on October 6, 1894—sister Ethel's eighth wedding anniversary. The first was a high noon Mass in a Catholic church and then an Episcopalian service. A celebratory luncheon followed at the Hotel Bristol, and the honeymoon was in Holland. They made their home in the San Francisco area in a home, Sky Farm, built by the Crockers as a wedding gift. It is now home to Nueva School, an independent facility for gifted children. The prince went into business with his brother-in-law in a syndicate reviving dormant gold mines in Amador and Calaveras Counties, the Standard Electric Company. The Electra Power House was built and sent power to the Bay Area beginning in 1902. He later received the French Legion of Honor.

The Sperry sisters devoted themselves to both social and philanthropic interests before World War I. Both attended the coronation ceremonies of King George V of England in 1910. Each couple had four children. All the cousins were bilingual and lived both in France and America.

The Crockers grew in many Californians' estimation when the debris of the 1906 San Francisco earthquake and fire settled and the couple went to work restoring the city. The two mansions atop Nob Hill were gone. Crocker won the praise of oil executive William F. Humphrey, who said Crocker "stood out…[in] the role he played in the drama of San Francisco's business." He started with rebuilding the Crocker buildings, and Ethel organized and established kitchens in Union Square, directing the cooking and serving of free hot meals. She took on hospital work as well.

They continued to work stoically even though much of their art collection was lost. Ethel was a leading collector of French impressionist art and displayed Monets, Pissarros and Renoirs during her lifetime. A friend, Bruce Porter, arranged to enter the mansion under permission of a Crocker representative, which ensured he wasn't shot for looting. He left with a Corot and a Rousseau, *In the Forest*, and Millet's *Man with a Hoe*.

The couple decided not to rebuild in San Francisco. They donated the entire block to the Episcopal Church as the site for Grace Cathedral.

The two focused on building their Burlingame home, which they termed New Place, in 1912–15. It was a sixty-seven-room vacation place, once called the most beautiful in the state, with 523 landscaped acres. The home is now the Burlingame Country Club.

The princess displayed a love of art as well and was painted by Giovanni Boldini, an Italian artist. He was noted for his flowing style and also painted Ethel's daughter and namesake, who became the Countess de Limur.

On the advent of World War I, Ethel joined with future president Herbert Hoover in the Belgian Relief Organization and gave freely to various charities connected with the war, including the American Ambulance Corps, the French Children's Refugee Fund and the Mutilated Soldiers Fund. She also built a huge American hospital in Paris.

But more astonishing, she rebuilt a tiny twelfth-century French village destroyed during the war. Vitrimont fell when advancing German troops scattered the villagers and obliterated its historic houses and livestock. Hoover was one who was behind the restoration work. Mrs. Crocker learned from an associate in 1916 that the church bell rang for the first time since the disaster in 1914. That Christmas, Allied troops arrived to help the fortunate villagers celebrate. Lucky Vitrimont had wider streets and sanitation facilities, but otherwise "new" Vitrimont was identical to the original. The village sent its thanks to the "Lady of California."

The Crockers had numerous properties throughout the state. The Crocker-Sperry ranch, Rancho Las Fuentes, or Ranch of the Flowing Springs, in Montecito was among them. Caroline Elizabeth Sperry, the sisters' mother, had her name added to the deed in 1890, and the ranch became known as the Crocker-Sperry Ranch. After her death in the early 1900s, she bequeathed her share of the estate to Beth Poniatowski. Eventually, some sites were sold to the Valley Club of Montecito for its clubhouse and golf course. The princess died in 1947. Her son Prince Casimir lived on the Montecito ranch, managing property for the siblings. Casimir was a native Californian, born in Ethel's Nob Hill mansion in 1897.

Ethel Crocker died in 1934 and is buried in Colma. Her husband, before his death in 1937, recalled his early life in Sacramento, remembering his childhood in "a little house under a willow tree."

Julia Weber

Stockton's Own Royalty

I f Helen Murphy Weber, wife of Stockton founder Charles Weber, were the city's first lady, then her daughter, comely Julia Weber, could be considered Stockton royalty. She lived an educated, independent life, dividing her time among the social, the philanthropic and the business pursuits of the day.

Her parents had ventured to California well before the gold rush. Charles Weber, a German immigrant, had been granted Rancho El Campo de los Franceses, including both Stockton and French Camp, and partnered with William Gulnac to form a colony at French Camp. The peninsula known as Weber Point was chosen by Weber for his notable adobe, where he and his wife reared their family of three children. When gold was discovered, Weber was ready for business. The 1850 United States Census showed 3,647 residents from throughout the world had settled in San Joaquin County.

By the 1890s, Stockton had shown significant prosperity as agriculture flourished and it became a major industrial and transportation center. Wheat, once dominant, gave way to fruits and a variety of other crops. Julia, the founder's only daughter, proved herself a businesswoman after her parents' deaths. She gave her brother Charles control of the family's residential properties and took on agricultural interests. She managed several ranches, raising barley and planting a cherry and walnut orchard. Her vineyard claimed more than 150 acres.

The curly-haired girl grew into such a renowned and beloved Stockton personage that local flags were hung at half-staff on her death at eighty-two. Her parents educated their only daughter at the Stockton Female Institute

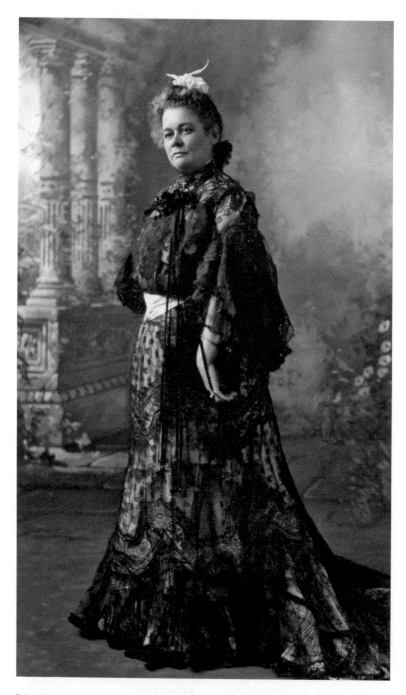

Julia Weber was Stockton royalty and loved to play the part. *Courtesy of the San Joaquin County Historical Society & Museum.*

on El Dorado between Flora and Park Streets. The school was the work of Dr. Henry W. Hunt and was devoted to music, art and languages. It closed in 1873.

For her expanded learning experience, the Roman Catholic Webers chose the Academy and College of Notre Dame in San Jose, which began as an adobe building in 1851. It was chartered in 1868 as the first college in the state to grant a baccalaureate degree to women. Julia studied there for eight years (through high school and college) until 1872.

Her education completed, the lovely Miss Weber, who enjoyed traveling to San Francisco with friends and relatives to have her portrait taken, returned to the historic adobe she called home. An adventurous person, she traveled to Alaska, Hawaii and Mexico; attended theater programs here and in San Francisco; and enjoyed bicycling, horse and dog races and baseball games.

The adobe, by this time, was showing definite signs of wear. It had been built in 1841 on what was called Weber Peninsula, or Observation Point, near McLeod's Lake. Floods had weakened the walls, and by the early 1890s, she and her brother Charles decided to design a new Victorian residence at what was now called Weber Point. In later years, it was known as Lindsay Point.

They left the old adobe to fall into ruin and become a hobo camp. The new residence, of two thousand square feet, was exquisite, containing a library, numerous second-floor bedrooms, a dining room and a kitchen area. Her mother's death in 1895 caused Julia to think again about her life's residence. Did she wish to stay on at Weber Point? She thought the peninsula land too expensive for residential purposes yet was concerned about deterioration of the area. Should she move her new home to one of her many Stockton properties by the Calaveras River?

It certainly had occurred to Miss Weber by now, in her mid-forties, that she would not marry. In the mid-1880s, she had a serious beau, John Wakefield Ferris, an Englishman four years her senior. A civil engineer in San Francisco, Ferris had business interests in Stockton and apparently fell quite in love with Miss Weber, who was always dressed to perfection in the Victorian manner, with gloves, flowers and large picture hats. Julia's close friend Anna Peters, wife of steamship line president J.D. Peters, even stopped him on the street near his Main Street office to encourage his suit and acted as a go-between for the couple.

Ferris was destined to go the way of Julia's other suitors—on to other, more marriage-friendly girls. Certainly the woman he eventually married, Emma Spreckels Watson, daughter of sugar tycoon Claus Spreckels of San Francisco, was of this ilk. She had eloped from her father's mansion

with Thomas Watson, a San Francisco broker, and had hit the headlines when she returned $1,500,000 in bonds and property to her father when he complained about the union. Watson died in England in 1904, and two years later, Mrs. Watson wed John Ferris in New York.

Julia Helen Weber marked the new century by moving her home from the Weber Point location to her ranch north of the Calaveras River on West Lane. The original kitchen and dining room had been housed in a separate building connected to the main house by a corridor. At the new location, she utilized the space as a guest cottage. There was no indoor plumbing until after her death in 1935, when relatives took over the home.

As for her new garden, two date palms, which she and her brother had planted when young, were transplanted from the old place, along with a rose garden and numerous other favorite plants.

The house became known as Helen's Oaks. It took three Holt Company steam traction engines to move the residence. Staying with her through the move was her devoted Ellen "Nellie" Geoghan Quinn, born in Ireland in 1867. She came to this country in 1890 and was offered twenty dollars a month as an aide to Julia. She died in 1945. It was Nellie who drove the heiress to her Stockton engagements in one of two vehicles: a wicker-sided buggy for summer and a high-sided one for the winter.

There were plenty of occasions for driving Miss Julia. "Lady" Constance Miller, a local legend for her many hats and as the longtime Stockton city clerk, would join the impeccably dressed Julia at afternoon teas for this or that "aid society." As a teenager, Miss Miller was thrilled to be invited to hold the silver tea service. The Stockton residences were of the highest caliber and taste, she recalled: the interiors had high ceilings, with plenty of wall space for family portraits and oil paintings "in magnificent gold frames." Tall, narrow windows were hung with "ecrunet embellished with Battenburg scrolls, the design blending into frescoed ceilings." Marble fireplaces were decorated with candelabra, which she called girandoles, and such "continental" adornments as bisque statuettes or vases.

The visiting women and their hostess paused for tea with hats on, wearing custom-made ensembles, sitting on furniture made from walnut or fruitwood, "in Stockton usually the work of Martin Schneider." One might observe a piano, a music box, a family album. Service was offered by young people of the town, but inevitably a servant was in charge—Stocktonians hired Irish, Japanese and Chinese as cooks.

Most impressive of all the homes in town was the Laogier estate, once on the extreme outskirts of Stockton on North Street, now Harding Way. With

the quarter million her husband, Basilio, left, Dionisia Laogier erected a lavish residence that was called a historic landmark when it was torn down for a filling station in 1950. A three-story rococo house with the obligatory cupola, the thirteen-room home was ranked high in magnificence with handpainted frescoes and a large, comfortable porch.

In 1910, Mrs. Laogier was ensconced in her mansion with a son; a daughter and her husband; and three servants from Denmark, Spain and Italy. She was the widow of Basilio Laogier, a member of the San Joaquin Society of California Pioneers. He was born in what is now part of France in 1820, arriving in San Francisco in 1850 and trying his mining skills at Mokelumne Hill. Leaving mining, he opened a locksmith business in Stockton and eventually settled on pack trains, hauling goods to Murphy's and Virginia City. After deserting this business and doing more traveling around the state, he returned to Stockton, becoming a broker, grocer and real estate agent. He married Dionisia Ponce in 1869; according to the *Illustrated History of San Joaquin County*, she was a direct descendant of Ponce de Leon and was born in Mexico.

The widow had a court fight on her hands when a daughter of the late pioneer, Virginia Leon of Mazatlan, Mexico, claimed a $1,000 share of the $200,000 estate. Mrs. Laogier contended she was illegitimate, and the court threw out Leon's request in 1898.

Julia and Dionisia, as leading single women of the city, were fast friends. They were both members of the Philomathean Club, Stockton's premier association for women. Julia served on the board of directors in 1909–11 and the Building Committee, through which its grand clubhouse was built in 1911–12. The two most famously gave the money for the purchase of land for St. Joseph's Hospital. Major J.D. Peters also gave funds so that the hospital could open on December 21, 1899. The Dominican Sisters of San Rafael operated the twenty-five-bed facility. The hospital property of 9.23 acres was purchased by Father William B. O'Connor on ground north of the city limits facing California Street. Today, St. Joseph's is a thriving regional medical center.

Other interests of Julia's were the YLI (Young Ladies Institute), and the Weber Institute No. 49 was named for her. She was grand president of the State Catholic Ladies Aid Society and served on the board of the Women's Syndicate of San Joaquin County, which encouraged women to invest in real estate.

After Julia's death, the house was cared for by her niece Helen Weber Kennedy and her husband, Gerald. Julia took the girl under her wing after

her mother died, also giving considerable attention to Helen's younger brother Charles Martin Weber. Helen's education was at the Academy of Notre Dame and the University of California, graduating in 1913 with an agriculture major, the first woman to do so.

Julia's home is now at the San Joaquin County Historical Society and Museum at Micke Grove Park in Lodi.

Inez Budd

California's First Lady

S wathed in an unusual pairing of tropical plants and evergreens, the magnificent dome arching more than two hundred feet, the California state capitol awaited its influx of diamonds, ostrich plumes, satin and lace. Hundreds of well-wishers of the new governor, James H. Budd of Stockton, arrived in carriages on a mild midwinter Sacramento night in 1895 for his grand inaugural ball.

Having been mainly reared and educated in the booming river city of Stockton, "Smilin' Jim" Budd had become a community leader with an established family unit—including a brilliant brother, John—and his own national fame. He had served in Congress and now had just pulled off another hard-fought upset win, this time for governor.

Large portraits of the new governor and his wife and childhood sweetheart, Inez, were placed amidst the national colors draped across the great transom over the main doorway. As the 1,200 guests entered the brilliantly lighted rotunda, music from above led the merrymakers into the Senate and Assembly chambers, also lavishly decorated.

It is almost certain that the new first lady of California, Inez Budd, seized all eyes as she glided underneath her portrait among the bunting. She was resplendent in an impressive gown that stands as her testament as California's first lady—in fact, the only mention of her in that role was the *Sacramento Daily Union*'s description of the gown, in captivating detail.

In a day and age when a woman was known for the fashions she wore as much as for the company she kept, Mrs. Budd's attire was a hot topic both

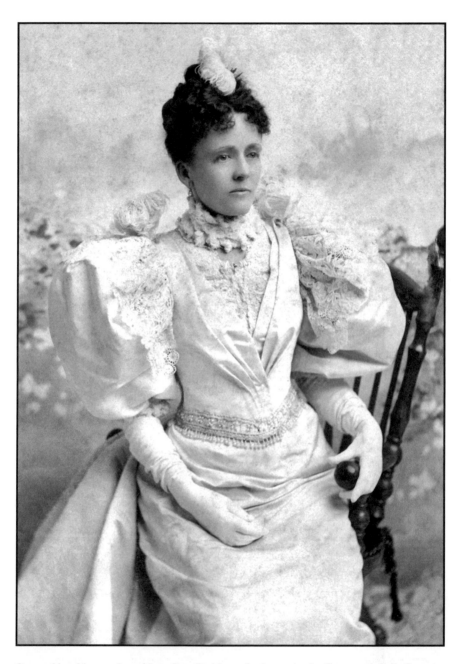

Gowned in white pearls and lace, Inez Budd caught the eye at the Governor's Ball. *Courtesy of the Haggin Museum.*

that evening and in the next day's newspapers. The décolleté dress of white duchesse satin was accented with pearls and lace and featured bouffant sleeves edged with bands of small white ostrich tips. Diamond ornaments embellished her hair, worn in an upswept style, and she carried a bouquet of white rosebuds.

Among those drawing up toward the Tenth Street portico where a canopy was erected, just in case the weather took a turn for the worse, was a contingent from Stockton, the governor's home since his magistrate father, Joseph H. Budd, moved the family west from Wisconsin in the late 1850s. They now had strong roots in the town that had sprung from tule grass and miners' tents.

Amid the gaiety surely little was said aloud about the embarrassing details of an old scandal raked up in California newspapers by Budd opponents hoping to sway voters. Republicans had a field day with the story reported in the October 20, 1894, *San Francisco Evening Post* about the teenage ward whom Budd had allegedly seduced, impregnated, swindled and left to die in a San Francisco pesthouse after giving birth to a baby who also expired. The Nancy Neff affair dated from the 1870s but became fresh front-page news in an election year.

It took the *Los Angeles Herald* to clear the allegations against Budd four days later. Charges in the suit by the Neff parents were declared "baseless" in Oregon Superior Court in 1886, the newspaper said, and Budd went on to win the California governorship against Morris M. Estee. The *Stockton Daily Independent* made no mention of the uproar when, on October 24, it covered the Estee campaign and his appearance before a crowd of eight thousand Stockton Republicans and onlookers. Nor did Estee make any reference to the scandal. There were also allegations of voter fraud; an assembly committee investigated, but no wrongdoing was ever proven.

It was a difficult series of developments for the dignified Mrs. Budd. She and her husband had been close childhood friends, meeting in the same grammar school class. Inez, born in Connecticut in 1851, had been brought to Stockton as a child by her parents, Marcus and Celinda Merrill. She married in October 1873, and the Neff affair dated from the late 1870s. As she would drift through her life as a California governor's wife, what could have prepared her for yet another cruel assertion—yet another affair, this time called the "Dumouriez Mystery" in San Francisco newspapers. It was little wonder, Stocktonians would whisper, that Inez looked to the heavens for solace and inspiration, turning portions of her Channel Street home in Stockton into an observatory and forming her own religious cult.

They had married before Budd's graduation as one of twelve members of the first University of California graduating class in 1873. His classes, beginning in 1869, were in Oakland at the former College of California at the corner of Thirteenth and Franklin Streets. The new university moved to Berkeley in the fall of 1873.

The young couple campaigned together during his run for Congress as James Budd earned the nickname "Buckboard Jim" by shunning railroad travel for the dependable buckboard, with Inez often by his side. They made their home at 1239 East Channel Street. James practiced law, and soon politics filled their lives; they had no children.

Budd's one term as governor passed sedately. He is credited with starting the move to create the Bureau of Highways in 1895, which was involved in construction and maintenance of state roads. It was a forerunner of the California Department of Transportation. Budd also OKed purchase of the Lake Tahoe Wagon Road; the first state highway, it is now part of U.S. Highway 50. The National Governors Association biography says that "he accomplished very little due to the Republican-dominated legislature."

Budd gave "failing health" as one reason not to seek reelection in 1898 and was replaced by Henry Gage, a Republican, in 1899. He did not retire to Stockton but opened a law practice in San Francisco. He also was the attorney for the Board of the State Harbor Commission.

There were also trips to Europe to regain his health. Unfortunately, after his death, reportedly from Bright's disease, on July 30, 1908, it was published that some of those excursions were taken with a woman who was known to the family but whose relationship with and kinship to Budd were murky. A wealthy woman herself, Daisy Zilla Dumouriez had a villa on the French Riviera near Nice, a daughter and two previous husbands. It was a stunning blow to Inez Budd and the entire family.

The trouble surfaced when Inez Budd and Mrs. Dumouriez both recorded a deed to the same piece of San Francisco property. Mrs. Dumouriez, the day after Budd's death, transferred the two lots to her daughter, Lena Ashley. Inez Budd, acting four days later, recorded a deed of prior date transferring the same property from Mrs. Dumouriez to Governor Budd's estate.

A furor arose, most prominently in the pages of the *San Francisco Call*. The page-one photo showed Mrs. Budd and the "mystery woman" squared off with Budd below and between them. Mrs. Dumouriez was said to be a wealthy woman—either through family inheritance or by funds given her by Governor Budd, which Budd's wife alleged. "I think that Mr. Budd gave Mrs. Dumouriez a great deal of property," she told the newspaper.

Mrs. Dumouriez reportedly held interests in Nevada mines, claimed property in San Francisco, lived in upscale Belmont and, most impressively, drove her own automobile. Tongues were further set wagging when the two Mrs. Budds—mother and wife—differed on the touchy subject of which woman should get the property. Budd's mother, Lucinda, came down firmly on the side of Mrs. Dumouriez, calling herself a friend of the woman and welcoming her and her daughter to her Stockton mansion on North Sutter Street while her son lay dying blocks away at 1239 East Channel Street.

Inez Budd had been living a life somewhat separated from her husband after his state service. Given her own income by Budd in 1902, she began a scholarly study of the Bible and combined it with her fascination with astrology. Christ's Doctrine Revealed and Astronomical Science Association was later incorporated, and the small sect was left funds for its continuation in her 1911 will, although that provision was later thrown out, along with a bequest of $2,500 to the Stockton Public Library. The sect's devotees were all present at Inez Budd's funeral in 1911.

While seeking to dislodge the mysterious Mrs. Dumouriez of her claim to Governor Budd's property, Inez appeared unwilling to divulge any knowledge of the true relationship between her husband and the claimant. The *San Francisco Call* claimed in August 1908 that Mrs. Dumouriez was the illegitimate daughter of the governor's father, the illustrious Judge Budd, with James Budd acting as her guardian "in order to conceal his father's wrong."

The Dumouriez affair appeared to come to a mercifully quick end. By early 1909, any claim to the estate was dropped by the San Francisco woman, and she ceased to be mentioned in further newspaper articles—until Lucinda Budd stirred the scandal again in the summer of 1909 when she sent out cards announcing the marriage of Mrs. Dumouriez to former congressman Edward de Nivernais, identifying the bride as her granddaughter. Stockton was aghast again, and Inez Budd denied the relationship.

But a heretofore quiet member of the family, Mary Budd, spoke up with her recollections that Mrs. Daisy Dumouriez's mother was a young widow known by both Budd brothers while Governor Budd was attending the university in Oakland, well before his marriage. The widow and James Budd had had a child who became the "mystery woman," Mrs. Dumouriez. "We have all known it for years," she contended.

Inez Budd continued to entertain groups of friends and concentrated on charitable work, giving away much of the money and properties left to her by her husband. She remained thoroughly fascinated by the considerably

large telescope and "observatory" at her home. "I want to understand what they mean—I want to go deeper than most astronomers have gone," she told a hometown newspaper in 1901. She confided that she thought that other planets and the moon were inhabited. She hosted "planet parties"; one of the most successful was given in 1910 when Halley's comet was observed by fifty friends.

Her religious duties also continued, and she taught a class in her home to Christ's Doctrine devotees the afternoon before her death of heart disease.

L. Clare Davis

Club Founder and Enterprising Journalist

A sudden cold wind had furiously blown into the usually dust-cloaked Central Valley farming town of Stockton, leveling a tall chimney on a new residence at Poplar and Otter Streets and demolishing the west end of the Holt Brothers' Aurora Street business. But mere blustery weather was nothing that would change the evening plans of journalist L. Clare Davis, who was that night in 1893 planning to start a women's study club in a town made suddenly dreary by the late fall skies.

She and a small group of other prominent women had decided: it was time to bring a bit of culture to Stockton for themselves and their circle of friends. It would be an organization like so many others newly popular across the country—an organization for women that would enrich their minds. It would also be a source of learning and camaraderie in an agricultural, railroad and inland port of more than fourteen thousand that many of these women, most hailing from important eastern backgrounds and ancestry, found lacking in the areas of culture and education.

Davis was a pioneer in myriad ways—she was raising her small son Shelden alone, having divorced his contractor father, and she was supporting them both as a full-time newsroom employee at the *Stockton Daily Mail*. She was also socially prominent and took an active interest in local business endeavors.

L. Clare had the education and a professional position that could inspire local women whose own gifts were unused or unappreciated. As the sole woman in the all-male newsroom—in fact, only the second woman in Stockton

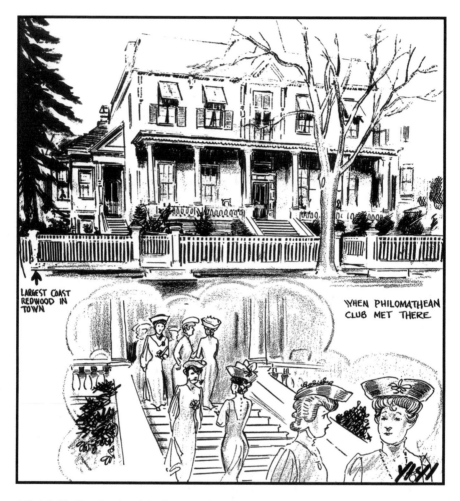

A Ralph Yardley sketch, originally in the *Stockton Record*, of the elegant Philomathean Club House built in 1912. L. Clare Davis was among the group's founders. *Courtesy of the Bank of Stockton Archives.*

to hold such a job—she was a prime example of what a woman could become: independent, self-reliant and knowledgeable about public issues.

She and the others invited—among them the woman who called the meeting, Margaret Davis (no relation to L. Clare)—began the short trek to the lavish home of Eva Cross on fashionable North El Dorado Street to become part of a remarkable organization that has thrived into its second century.

The early evening of November 17, 1893, had been chosen by Margaret, the strong-willed wife of a prominent area farmer, as the date the study club

would begin, composed of a group of friends and neighbors desirous of enrichment through "promotion of study, the cultivation of literary tastes, and the encouragement of freedom in discussion." The society leaders were shown into one of the grand late Victorian homes that once lined North El Dorado Street. The hostess was the wife of Dr. Samuel N. Cross, one of the most prominent physicians in the city.

Among the arrivals for the meeting were Edna Orr James, the daughter of former state senator Nelson M. Orr; Adelaide Nicol, a well-known lawyer's wife; Kittie L. Crawford, who would become a fixture in the club and change last names twice before her death in 1944; Pernesie Yolland, spouse of the San Joaquin County clerk; Margaret Davis's daughter, Maude; and Alice Ackley, Mrs. Cross's sister.

The officers were quickly chosen. Margaret would be the president, later referred to in club material as "The Mother of the Club." Mrs. Cross was vice-president, and Maude Davis took on treasurer duties. Edna James became the librarian and Mrs. Yolland the secretary. As noted in the margin of the minute book, "These nine alone were the original members who formed the club." It was stated in the bylaws, "The name of the society shall be The Ladies Reading Club...Its object, literary pursuits."

The dynamic L. Clare, as she was always called, helped the organization change from this tiny study club into a forceful, powerful group that is marking its 120th year in the Stockton community in 2014. On January 26, 1894, the group formally became the Ladies Philomathean Club, the term *philomath* meaning "lover of learning," probably of Greek origin.

The founder most recognized by her adopted city and, indeed, celebrated through the state for her professional prowess was L. Clare Davis, who developed into one of the first California female newspaper columnists. She was given great leeway by the *Daily Mail* editors to write on any subject she so desired. Daughter of a Bavarian shoemaker who lived in Georgetown, California, the former Lizzie Husse (not at all fond of her childhood name, as it was shared by the notorious axe murderess Lizzie Borden) eventually decided her byline would read "L. Clare" and began her career as a journalist on the *Sacramento Bee*, moving later to the *Fresno Expositor*. She had become interested in education first, graduating from Georgetown schools and teaching in a one-room schoolhouse in the El Dorado County area.

Sometime before the end of the 1880s, she married contractor and builder A.L. Davis, who hailed from Oakland; together they had a son, Shelden, born in Stockton in 1887, and from that time the figure of Mr. Davis disappeared from their lives. They lived at 141 Center Street through

the early 1890s. By 1894, just L. Clare and Shelden had moved to 133 West Park Street. "Neither of them spoke of him," recounts one of her few close relatives, a great-nephew, Fredrick Husse of Auburn, of Mr. Davis.

Petite and forthright, L. Clare began locally with the *Mail* probably soon after Shelden's birth. She had many irons in the fire during the 1890s, among them partnering with P.A. Buell, a wealthy planing mill owner, and other city leaders on promoting the Stockton & San Joaquin Valley Railroad line. She continued her local involvement in the schools and was repeatedly elected to the Stockton Board of Education, retiring in 1911 after fourteen years. Her position on the school board was even advocated by the *Mail's* opposing newspaper, the *Stockton Evening Record*, which hired her and her son years later when the *Mail* folded. She was in one election year approved by both Republicans and Democrats.

"She was an independent lady, with her own ideas," recalls Husse, who has vivid memories of "Nina," as she was known to the family, though he was only about ten years old when she died in 1947. Nina's beloved son and co-worker, Shelden, had passed away the previous year of arteriosclerosis.

"She was a mentor—and if she liked you, she'd go to the end of the earth for you," he says. The Husse relatives were frequently welcomed to L. Clare's North San Joaquin Street residence, especially for Thanksgiving dinners. Her Hepplewhite dining room set, complete with sideboard and china closet, was an example "of her outstanding taste." Husse's father inherited it and literally rebuilt his Auburn home to include it.

She remained devoted to her family. Tombstones for both parents (Elizabeth in 1887 and her father, Lawrence, in 1908) were sent up to Georgetown from Stockton by stagecoach.

L. Clare's home—always with Shelden—reflected that perfect taste. "It radiated *her*," concludes her great-nephew. The two newswriters—for Shelden joined her on the *Mail* after his graduation from Stanford University—were by the 1920 federal census at 1721 North San Joaquin, in the fashionable Bours Park neighborhood. Like its owner, the residence was small and stately, a turn-of-the-century home with a comfortable covered front porch leading into a hall that opened to French doors on the left that secluded the living room. The family gathered for holidays in the dining room, overlooking the backyard.

Thrilled when Shelden graduated from Stanford, L. Clare continued to work full time with a popular column while her son was hired as a newsman. In 1917, both moved to the *Stockton Record* and sat side by side as she wrote "Along Highways and Byways," a chatty record of local and international events, and he penned editorials. Before "Along Highways," her column was called "Passed by the Censor." It ran under the *Record's* editorial cartoon.

"They were a wonderful team in home and office," one story about her attests. "Each took delight in good literature and culture and in all the wholesome things of living…nature, the mountains and lakes. Each was deeply interested and informed on the lore and history of California."

L. Clare became a dogged newswoman, noted to publishers and editors throughout the state for her copywriting and reporting skills. "An aversion to hypocrisy and false pride was reflected in Mrs. Davis' style of prose, simple enough for anyone to understand and yet sparkling without superficial gloss," an editor noted. She waged a lifelong campaign for Stockton's historic trees through her membership in the Stockton Arbor Club and also gained friendship from those who were featured in her human interest articles.

Fellow reporters, mostly all men, were reluctant to call her Clare, yet "Mrs. Davis" seemed too formal an address for someone who expressed kindness to, and interest in, her colleagues, so they called her L. Clare, just as her social acquaintances did.

The energy seemed to run out for the noted Stockton women's leader when she took a fall from a streetcar in 1929, injuring her back and forcing her retirement from the *Stockton Record* about three years later. She and her son became close friends with fellow newsmen Wilbur Krenz, a printer, and Jack Trantham, a stereotyper. L. Clare considered them adopted sons, even after their marriages. Trantham was there to inform the bereaved parent of the death of her son, who passed away suddenly a year before his mother. On her death in 1947, they were buried beside each other in Stockton Rural Cemetery.

L. Clare often recalled her days as plain Lizzie Husse in her columns and retained a breezy, no-nonsense view of life. In one *Mail* column printed in the *Reno Evening Gazette*, she was called "one of the most brilliant newspaper writers of California." Her article was all about Nevada senator George S. Nixon, who had grown up with her in the California foothills. "Though we didn't exactly make mud pies together, we swung on the garden gate, roamed over the Placer hills gathering wild flowers, and told each other our dreams," she recalled in the 1904 column.

She contributed to California magazines, including *Sunset*, and her bon mots were also extensively chronicled and reprinted. One, called "A Woman's Honest Confession," appeared in the 1897 *Los Angeles Herald* years after her work on the *Expositor*, in which she first published it. The sentence was typical, down-to-earth L. Clare: "I'm free to confess that a good, strong, well-meaning 'damn' in the right place often causes me to utter a pronounced, deep-drawn sigh."

Sarah Gillis

She Ran the Steamships

Impetuous and yet with a serious demeanor learned after a devastating marriage, Sarah Hayes Gillis had followed the Argonauts who landed in San Francisco for the gold rush. The men quickly learned that the easiest way to the gold fields was by way of the "river route" to Stockton. From ten to eighteen dollars per cabin—less if one wanted to sleep alfresco on the deck—a prospective miner could arrive at the kickoff point in two or fifteen days, depending on the wind. Eventually, many steamers came to replace the sailing vessels, crowding into the head of the Stockton Channel and McLeod's Lake.

Waiting for the newcomers was Captain Charles Weber, town founder, who started San Joaquin River shipping with a two-masted sailing sloop in 1847. Soon there were so many boats abandoned as the crews and passengers headed to the mines that they were hauled to Mormon Slough and burned. Shipping became a big business, and at least one miner-turned-businessman/landowner/farmer thought he could enter the waterways with a new company that would vie with the established California Steam Navigation Company.

The upstart in this successful shipping business was James Gillis. The woman who was to join him in a life of landed luxury and the thrills of steamboating would arrive a quarter century later after the death of three children and her first husband. Gillis, a New York native and one of thirteen children, left home for California in 1851 at age twenty-two, crossing the Isthmus of Panama by skiff and by foot, his ordeal on the narrow lane from

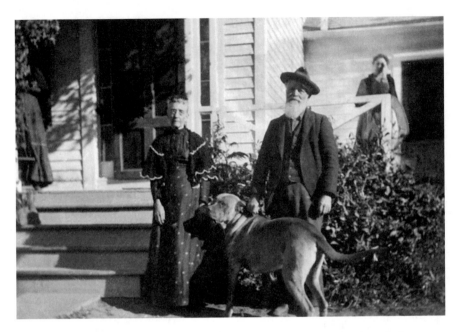

Sarah Gillis and her husband, James, loved Elmwood Farm and running the steamboats. *Courtesy of Alan "Sandy" Smith and Isolee Smith.*

Gorgona becoming a tramp through a trough instead of a path as the wet season in which he passed turned the terrain into a swampy ooze, with mud up to five feet deep. He reached San Francisco on the *Winfield Scott* in July 1851 and made the same beeline for the mines.

Gillis was profoundly deaf since an unspecified illness or accident at age twenty-five. He was a tall young man with a gentle sense of humor. He headed toward the Sonora mining area. Quickly deciding that mining was not for him (although he did retain mining interests), he joined with a partner to sell soda water—a lifelong teetotaler, he realized the hard-living miners couldn't drink whiskey and beer all the time. He made a considerable amount of money, investing it in San Joaquin County land, eventually settling on one portion and raising wheat and barley. He married Mary Taggart, his first wife, in 1863; she died in 1872, soon after the "big house," as it came to be called in the family, was built. She left Gillis the single father of two girls. Officially, the property was known as Elmwood Farm.

The 357 acres on the Copperopolis Road became a paradise of sorts for Gillis and his young family. The property flooded each winter—as did most of the city of Stockton—but the deluge of silt managed to enrich the

land. On other farmland Gillis owned, some 2,000 acres were covered by vineyards, along with other crops.

Sometime in the 1870s, Gillis met the woman he would build another family with: Sarah Hayes Scott. The young widow had come to California with her military husband sometime after the Civil War. Sarah, born in Ohio, was sent by her parents, John Hayes, originally of New York, and her mother, Amelia Rigby Hayes of Ohio, to the Monticello Seminary in Alton, Illinois, an all-women's establishment encouraging students' intellectual and domestic skills, as well as their sense of morals. Alas for her parents and the seminary, the sixteen-year-old fell for a Captain Scott, who "inveigled her to run away and marry him," as a daughter described the adventure that took the eloping couple away from her family and education and into a military life that resulted in four children, of whom only one survived, Hugh Scott. Injured in the war, the captain hoped to recover in California, instead dying, perhaps from those war injuries.

The family has determined, through Gillis's 1877 farm ledger records, that Sarah first became a housekeeper/chaperone for the Gillis daughters Jessie, thirteen, and Edna, eleven. A year later, the couple married. In the 1880 census, thirty-five-year-old Sarah and her ten-year-old son were living at Elmwood Farm with James, now fifty-one; his daughters Jessie and Edna, now sixteen and fourteen, respectively; and one-year-old Jennie (Jeannette). Twenty years later, the family was established with Jeannette, Edna, fifteen-year-old Merren and James, fourteen, at home, with three boarders (workmen) and a twenty-four-year-old Japanese servant.

Merren recalled in a family memoir that her life on Elmwood Farm was a delight, filled with religious activities, music and a wide selection of pets—even a bat that Merren found in the barn and made a special friend. Especially treasured was a cat, Mother Whitenose, that would bring a choice new kitten from her litters to Merren and her brother.

Life changed for both Sarah and James during the 1890s, when he became interested in steamboating, then a flourishing business. River traffic from San Francisco was a necessity for the Southern Mines, and Stockton was essential to the shipping of supplies up to those miners.

Gillis was a leader in the Farmers' Union and Milling Company, builders of the Farmers' Union Mill. Owners refused to pay rates asked for by the California Navigation and Improvement Company (originally the California Steam Navigation Company), owned by Major J.D. Peters. Instead, Gillis formed another steamship line, the Union Transportation Company, buying the stock himself and building the steamers *Dauntless*

and *Captain Weber*. A deeply bitter transportation war began between the "old" and "new" lines. Both companies lost vast amounts as passengers were carried round trip to and from San Francisco for ten to twenty-five cents. Deadly serious as it was, the steamboat war enlivened an already boisterous waterfront, with the competing firms handing out cigars to passengers as they boarded, having previously been enticed by bands and even louder barkers cajoling the travelers. Allegations were made that the "old" line bored hundred of holes in the bottom of one of the competitors' boats. The companies stopped quarreling after several years and were folded into a Sacramento company.

While the "war" was tough, the Gillises loved their steamships. The rival companies would race their boats to the glee of a local audience. Once, a boat got stuck in the mud among the tules; it was a Gillis boat, and Sarah stayed aboard while the repairs went on.

As it developed, Sarah was so involved with the ships that she took over running the company as a major stockholder when her husband was kicked to death by a nervous horse. She ran the concern for two years and, as a temperance advocate, stopped selling liquor on the *Captain Weber*, famed as the fastest ship on the river, and the *Dauntless*. Neither of the "dry" ships had a bar onboard, although passengers could bring their own.

Sarah, until her death in the early 1930s, continued to be a temperance advocate (joining the Woman's Christian Temperance Union), businesswoman and society leader. The editorial/memorial that ran the day after her death called her remarkable, praising her femininity while appearing rather agog at her success in taking on the steamboat presidency. She also took charge of the Farmers' Union and Milling Company and operated the family farming holdings.

It was during the late 1880s and early 1890s that Sarah Gillis began to reach out into the community with her engaging and enterprising personality. The Gillis home became a showplace that saw the likes of Susan B. Anthony as one of hundreds of guests. (The national figure probably visited in May 1896, attending two conventions in the area.)

Sarah Gillis enjoyed parties, gatherings and other gaieties and furnished the home in exquisite taste. One alfresco theatrical fête featured the lush grounds to perfection. Inside, the home was one of the first in the area to have asphalt in the basement, finished with foot-square redwood posts. The huge space was dressed up to welcome at least one hundred guests.

Primary among Sarah Gillis's interests was the exclusive, women-only Philomathean Club. She was a moving force behind the building of the

club's now historic clubhouse in downtown Stockton and made sure that funding came through. She led the committee to solicit subscriptions for $10,000 worth of stock. On a late June evening in 1911, she hosted a gala picnic as a benefit for the Philomathean Club Building Society, specifically for furnishings. The party was an unofficial kickoff for the construction that had begun earlier in the week. Delicate Japanese lanterns illuminated the grounds, aided by headlamps of three large locomotive headlights provided by the Southern Pacific Railroad, until boisterous winds forced the gala occasion inside. The *Stockton Record*'s social editor pronounced Mrs. Gillis "ever a charming hostess" at her "pretty and commodious home."

One especially impressed by Mrs. Gillis and her talents was Robert Morton, who became Merren's husband and directed California's first modern paved highway program in San Joaquin County. He came to Stockton in 1908 as an engineer with the Bureau of Public Roads. By 1910, the couple was taking buggy rides. He found Merren "serious-minded" and her mother formidable. Despite Sarah's affinity for the Episcopal Church, Merren was a Presbyterian. Morton found himself in the middle of things after his marriage proposal—Sarah wanted a big wedding in one church, and his fiancée heartily disagreed. They decided to "elope" all the way from Elmwood Farm to Stockton, fewer than ten miles. He picked her up in the middle of December 1910 "in the county Hupmobile," and they were married in the First Presbyterian Church by the Reverend J.W. Lundy. They honeymooned in San Francisco, Los Angeles and the Riverside Hotel, then a popular newlywed spot. They came back early in January 1911 to face Sarah Gillis.

Sarah Gillis's confidence could also turn to imperiousness. Once, she insisted on driving to town in a horse and buggy. At the time of the fabled ride, automobiles were becoming popular, causing parking concerns. Sarah arrived for a meeting at the Washington Hotel, but all iron hitching posts were taken up with cars. She drove in circles around the block. Unable to "park" her horse, she stopped and tied him to the wheel of an automobile. A policeman who remonstrated her was told, "Well, I've been all around the block, and there's no place to park. Here, you take him." With that, she handed him the reins and walked off. "She had quite a reputation for little tricks like that," said Morton.

Portions of the Gillis estate are still in the immediate family. Twelve hundred acres bought in 1864 were spread throughout the county and into the Delta area. The Elmwood Farm acres fell between Copperopolis Road (now Main Street) and Sonora Road (now Farmington Road). Eugene Grunsky, a

land speculator, connected the Grunsky and Gillis families, marrying Jessie Gillis, James's daughter. The original home on the property became home to Jessie Grunsky's daughter, also named Jessie, who married Albert Matthews Smith, an ace tennis player and an estimator and draftsman in wood design for Union Planing Mill. Their son, the late Alan "Sandy" Smith, a Stockton attorney, inherited thirty-four acres on Gillis Road and bought back ten from other families. His forty-four acres are now a noted bird sanctuary run by his wife, Isolee. For more than twenty years, Gillis Grove, as it is called, hosted the Sunrise Rotary Club's early June wine tasting event, raising hundreds of thousands of dollars for local charities.

Lottie Ruggles

A Local Belle in Europe

Lottie Ruggles of Stockton was more than a century too late for a "grand tour," once considered by the wealthy as essential to finishing an upper-class education. Of course, these original "tourists" were the male members of the English elite. But during the late nineteenth century, wealthy Americans swarmed to Paris and Italy, collecting paintings and other objets d'art to bring back to the poor folks who couldn't make the journey. Often, such tours took a year or more to complete.

At twenty-seven, the lively, pretty and plump-faced only child of a Stockton newspaper publisher was eager to get across "the pond" and see the high points of antiquity and art, especially Rome. In a picture probably taken in her early twenties, she wears an enormous hat with aplomb and displays a mischievous countenance replete with a snub nose. She was encouraged in her fascination with travel by her grandfather, C.A. Ruggles, who before dying in 1906 was a noted physician whose work was respected throughout the state.

The Stockton doctor also enjoyed taking off on journeys to then-outrageous places. He was an authority on such diseases as leprosy, consumption and smallpox and served for four consecutive years as president of the State Board of Health. In order to do a special report on leprosy, having been selected for the work while vice-president of the National Conference of State Health Boards, he visited the leper colony of Molokai in the Hawaiian Islands. He also traveled to Mexico City as a representative for the national body at the Pan-American Conference. Often, Lottie would travel with him and delighted in becoming a world traveler.

Pretty Lottie Ruggles took a world tour and spent her life improving Stockton. *Courtesy of Trudy Kurey.*

By 1909, Lottie knew pretty much everyone in town and was a member of the popular and exclusive Philomathean Club, though as yet she hadn't taken an active role; eventually she would become its president. She and her parents, Charles Lincoln and Stella Ruggles, built a showplace home at 209 East Vine Street, so beloved that a professional photographer was brought in to record it for the family.

Known to all as Lottie, though her given name was Charlotte, she had been to a lifetime of teas, dinners, entertainments and even a gala street fair when she was but twenty-two. She served on the organizing committee for the event that saw a friend of hers, Genevieve Peters—later Mrs. C.L. Six—crowned queen. Helping her plan the occasion were Dionisia Laogier's daughter, Isabella, and Julia Weber, all socially active. She attended showers, engagement parties and weddings, but it soon became apparent that Miss Ruggles of Stockton was going to forever be a bridesmaid; she never married.

With no bridegroom to whisk her away on a European honeymoon, Lottie determined to see Europe on her own—sort of. She needed a companion, however, as in 1909 young ladies did not travel alone, either to San Francisco or to places abroad. Her choice was "Miss H.," as she referred to her in letters home, nineteen missives that are preserved in the archives of the California State Library.

The choice of Minnie Howell, a Stockton schoolteacher, to accompany the young socialite on her tour could have been made by the Ruggles parents, although the two women, separated in age by several decades, were associated by their interest in the arts. Minnie, born in Minnesota, started teaching English at Stockton High School in 1903, when the school was located in the Washington Grammar School at San Joaquin and Lindsay Streets. In 1904, the high school moved to a new building at California and Vine Streets.

As did Lottie, Minnie would flourish after her five months in Europe. Even before she left, big changes were made in the high school curriculum. The superintendent, James A. Barr, appointed a committee in 1900 to revamp teaching methods. The study was released three years later in several volumes and changed the educational system in Stockton. Where previously monthly written papers were delivered by students, along with occasional public oral examinations, by the time Minnie started teaching, she could promote a student on the basis of hers and the principal's judgment, with no public exams.

However important her teaching assignment, it is important to remember that then, as now, teacher pay was low. A public school teacher in 1910 averaged $485.00 a year, or $11,204.78 by today's standard; there were variations determined by region, teaching level and gender. Lottie did not have a career and was supported by her wealthy parents, while Minnie was apparently an independent working woman in one of the few fields open to women at the time. Her salary could hardly have stretched to such a lavish expenditure as a cultural tour. Minnie's father, Warren J. Howell, was a farmer in Placer

County before his death in 1898. Her mother, Mary Catherine Howell, had died in 1906. It is probable the Ruggles family paid both their expenses or paid Minnie a stipend to support her as Lottie's companion.

Once embarked on the journey, both were loath to return, especially the schoolteacher. "Miss H. dreads going back," Lottie shared. "It means the schoolroom…and a boardinghouse at night." The contrast between the two sobered her: "I have everything in the world to be thankful for," she concluded.

The Ruggles family could have afforded such an experience for their daughter, who was spoiled and cosseted and usually received whatever she asked for, a second cousin recalled years later. For forty-eight years, Ruggles (formally known as C. Lincoln) co-published the *Stockton Independent*, one of the oldest newspapers in the state, partnering with J.L. Phelps in 1884. Previously, Ruggles had been with the *Daily Evening Herald*. Moving to Stockton from Martinez as a youth, Ruggles began as a paper delivery boy and moved up to a reporter in 1880. He bought a half-interest in the firm but then signed on with Phelps. The *Herald* suspended operations and moved to Merced in 1885.

It would have cost each woman going on Cunard Lines RMS *Lucania* transatlantic from New York to Liverpool $102.50 first class ($2,430.00) and $52.50 second ($1,249.00). They took the Cunard ship *Carmania* to New York from Naples on December 9, 1909. First class would have cost them $97.50 ($2,310.00); second class, $55.00 ($1,300.00). Their hotels and baggage transfer probably cost $3.00 per day, possibly including all three meals, or $69.31 in 2010 dollars. It would cost Minnie, with $500.00 allowed for the hotels alone, all her yearly salary (if the two did not split the cost). Even had they split the hotels and if the cabins could be shared for a lower price, the expense would have been prohibitive. Minnie must have been quite well thought of to command such an extensive teaching sabbatical. It would most assuredly have been unpaid.

A similar grand tour, from a 1910 travel guide posted online by Gjenvick-Gjønvik Archives, allowed for at least four months from New York to Europe and back, at a cost of $750 to $900, "depending on hotels, the number of carriage rides taken, etc…Twenty years ago it was possible to make a trip of this kind as low as $660.00, but the cost of ocean transportation has somewhat increased," the guide estimates.

The travelers would have set off on a lengthy railway journey of probably five days from Stockton to the East Coast at the end of June. Lottie remarks in a letter from Milan, Italy, on October 23, "In four months we have been

going constantly." Round-trip railway service probably cost them a bit over $100. Allowing for four weeks aboard trains and ships, they probably spent twenty-four weeks in hotels, running up roughly $500 in hotel fees.

Once in England, the travelers started in Stratford, where they hoped to visit the Anne Hathaway cottage, still a tourist attraction, in nearby Warwickshire. Daily letters sent through Cook's Travel Service kept the folks at home aware of nearly every move, from beggars in Ireland to making the acquaintance of "a real count" and a duchess in Venice. Italian shoes were derided, Switzerland was breathtaking and Rome was termed exceptional.

"The vagabonds," as they called themselves, shared their experiences with their friends and organizations. In January 1910, home for just under a month, Lottie presented a paper on the Sistine Chapel at the Philomathean Club.

Later in the spring, she described Florence and its palaces, winding up with a discussion of Italian sculptors. Minnie surely was surprised by the local activities and accolades awaiting her. She was guest of honor at a luncheon given by her high school associates, and her experience was heralded in a newspaper article. She became active in the Stockton Schoolwoman's Club and was elected president in 1910. She finished her teaching career at Stockton High School with high honors.

Devoting herself to the Philomathean Club, Lottie threw herself into the building association for the Craftsman clubhouse the group built in 1912; it is now on the National Register of Historic Places. She began to share her progressive ideas. When a playground association was being formed in the city, Lottie represented the club at the sessions. Under her direction, the group supported the Stockton Chamber of Commerce and a "clean-up day lunch" held the next month. She headed the club's Civic Section in sprucing up and beautifying the community, one backyard and vacant lot at a time. She was elected president for the years 1915–17.

Lottie Ruggles would continue to be a social force in Stockton and in the Alameda District, General Federation of Women's Clubs, until the Philomatheans separated from the organization in the 1940s. She continued living in the Vine Street home until her death at eighty-six in 1968. In 1929, she and her parents took an extensive tour abroad and returned just in time for Christmas on the ship *Ventura* from Sydney, Australia. Her involvement with the Philomathean Club was so complete that in her obituary, she was incorrectly listed as a charter member.

Lottie left more than her community work as her legacy. In August 1960, she walked unannounced into the College of the Pacific office of Elliott J. Taylor and slapped down a stack of stocks. Telling the astonished director of

admissions that she wanted to start a scholarship in memory of her parents, she said the stocks were worth $12,200. That amount alone was expected to result in at least $400 annually. The Lincoln and Stella Ruggles Endowed Memorial Scholarship was enriched by more than $30,000 in her will. Lottie told the newspaper she wanted to see young college women progress, noting that she hadn't had that opportunity—she attended Stockton High School for two years and finished her high school education at York Academy, a private school located on the third floor of a downtown building. Today, the Pacific scholarship amount fluctuates from year to year, but for 2013, the amount of the bequest was $6,820.

Anna Brown Holt

Not a Socialite

The typical Stockton woman with a family or husband of some means became socially active in turn-of-the-century Stockton, and many lived within or near the fashionable Magnolia District, perhaps moving on to the swanky new Bours Park development as the twentieth century progressed. Anna Brown Holt ignored such fashion. She lived for years in an unattractive neighborhood that included a brewery and mental asylum grounds. The only "airs" she may have put on were purchasing new coats for her inventor/industrial magnate husband—and he refused to wear them. She ignored most Stockton society activities, primarily concentrating on family, church and prohibition gatherings. Later in life, watching the sea from her beachside home in Carmel, she would remark to her grandchildren that the activities of the Pebble Beach crowd had no attraction for her.

Anna Holt was focused on her five children, two "adopted" children and her brilliant if self-absorbed husband. For years, she had run a huge home with no help from servants, and even after her husband's death, she saw no reason to immediately move from her less than fashionable neighborhood, instead making many improvements.

Completing Anna's life on the "outside" of formal Stockton society was her husband, Benjamin Holt, the city's largest employer and a man who preferred his inventor's workroom and early evenings at the tavern over any social obligations.

Anna Brown Holt with one of her sons, Benjamin Dean Holt, possibly at University of the Pacific. *Courtesy of HOLT CAT Corporation.*

She was probably the wealthiest woman in Stockton. Certainly, on the death of her husband in 1920, Anna Brown Holt inherited one of the most valuable estates in San Joaquin County.

Disciplined, clever, energetic and capable, Anna Holt was reared a farm girl whose father had lost that farm and moved into Stockton to redraw

his life. Anna took business courses at Humphrey's College in Stockton and went to work at the Stockton Wheel Company, later Holt Brothers, in 1892 and, still later, the Holt Manufacturing Company on Aurora Street—the forerunner of the Caterpillar Corporation. A bookkeeper, she became the boss's personal secretary. Her income was undoubtedly welcomed at home. The family blamed Benjamin Brown's generosity in co-signing notes for his neighbors for having to move from the 320-acre wheat farm near Linden, where Anna was born in 1868.

Signing over the farm to J.L. Beecher of Stockton for one dollar, Brown moved the family to 312 East Park Street, Stockton. But soon Brown and his wife, Lucy, had their eye on what is now a residence on the National Register of Historic Places: 548 East Park Street. A white, wooden, two-story home, the residence was neighbored by the Rothenbush family's El Dorado Brewing Company and sat diagonally across from the state mental hospital. The Browns' youngest daughter, Mabel, recalled playing on the grass near the hospital's iron fence, watching for any antics from the patients inside. Mabel's sister Tessa Dean Holt married Fred Rothenbush, son of the brewery family.

A man with few pretentions, Ben Holt was used to walking around in a straw hat and wearing old clothes, topped by an even older overcoat, to keep warm in his drafty plant. Even after his marriage, he wore the old coat until his wife bought him a new, expensive one. He hung it in the hallway and continued to wear his old friend. Forgetting meals and using a succession of greasy rags to clean his hands as he tinkered with machinery, Holt was indistinguishable from many of his workers.

Apparently Holt, at the time of meeting Anna, did have a certain disheveled charm. He was five feet, nine inches with brown eyes and light brown hair and, like his secretary, had a no-nonsense air about him. At forty-one, the New Hampshire native had never married and devoted himself to work. While others "rambled on," he was silent; he was described as reserved, quiet, modest and generous and also as aloof and stern.

Always practical even though he was growing richer and earning the nickname the "Edison of the West," Holt married his young sweetheart in 1890 at her parents' Park Street home and moved in with them in 1895 to raise five children and also two others, Anna's niece and nephew. Their father, Charles A. Page, was killed in 1902 by an exploding furnace. Within several years, Benjamin Holt took over the mortgage.

Born in the year of the forty-niner, Holt had three brothers who worked with their father, William Knox Holt, running a family-operated factory

processing hardwoods for wagon and parts manufacturing in Concord, New Hampshire. This business continued until 1945. Charles Henry Holt was the first brother to leave the family business. He founded C.H. Holt and Company in San Francisco in 1865. It was later called Holt Brothers when William Harrison and Ames Frank Holt arrived in 1871 to join him. The company did not manufacture at this point but dealt in hardwood lumber for boat building, mining, freight-carrying wagons and stagecoaches.

When the brothers formed a new second company, the Stockton Wheel Company, in Stockton in 1883, Benjamin Holt came out from Concord to manage the business as an owner. Holt was recognized in the family for his mechanical genius and proved himself as such with his development of their combined harvester in 1886 and their first steam traction engine in 1890. Charles Henry Holt and Benjamin Holt incorporated their San Francisco and Stockton operations as the Holt Brothers Company of San Francisco and Holt Manufacturing Company (formerly Stockton Wheel Company), and Benjamin Holt became president of the new Holt Manufacturing Company in 1892.

Holt in 1893 invented and patented the side hill harvester for sloping land. A mechanism raised or lowered the combine wheels independently of one another, allowing the body of the harvester to remain level. It opened vast areas up to grain agriculture here and throughout the Pacific Northwest.

Holt traveled to England in 1903 to investigate developments of track-laying vehicles. He designed his own model, and in 1904, he had developed the world's first "practical" track-laying tractor. The company photographer said the machine moved like a caterpillar, and so the machine was named the Caterpillar. Holt is remembered today for his agricultural machinery and had more than one hundred inventions that significantly affected the mechanization of agriculture. His designs were the inspiration behind the World War I British tank, which adapted the track-laying principle to a metal-shrouded machine that could take enemy gunfire and plow over trenches and through barbed wire.

By 1918, Holt was the largest employer in Stockton; 2,500 people worked at his plant, which extended from Lafayette Street south along both sides of Aurora Street to Hazelton Avenue. He walked to work.

After her marriage, Anna Brown Holt kept to the homefront and welcomed five children: Alfred Brown, William Knox, Anne, Benjamin Dean and Edison Ames. The Holts lived at two Stockton residences before permanently settling with the Browns at 548 East Park Street. (The Browns eventually moved on to San Francisco with daughter Mabel.) Anna was in

full charge of the house, which in addition to its listing on the National Register of Historic Places is also a Stockton historic landmark.

"She had to be the boss," her second son, William K. "Bill" Holt, would say of her. "My father was so absorbed in his work he had no time for anything else. His only luxury was a glass of beer at a watering hole on his way home." His grueling workdays could last twelve hours. Otherwise, the inventor (without alcoholic refreshment, as his temperance movement wife allowed no alcohol in the home) kept to a small room on the second floor while his noisy family frolicked downstairs. One exception to his solitude was the popular Christmas party Anna hosted annually, inviting many Stocktonians.

As the Holts prospered, Anna was able to hire maids and handymen. The children were treated to picnics in Stockton parks and trips to the observatory at Mount Hamilton. Active for twenty-five years as a regent at the College of the Pacific, now the University of the Pacific, she was a member of Central Methodist Church and the Philomathean Club. Tully Knoles, who brought the college to Stockton in the early 1920s, credited Anna Holt for her help in advising him with the relocation: "Her advice was excellent, and her financial aid was greatly appreciated."

Holt's death at St. Joseph's Hospital the morning of December 5, 1920, after a ten-day illness, drew significant notice in California newspapers. The *Oakland Tribune* opined that his estate was "the most valuable ever administered in San Joaquin County," with half going to Anna and the property divided among their children. Holt's achievements won acclaim, and the company continued to flourish. It merged with Best Tractor Company in 1925, becoming Caterpillar Tractor Company. The family also continued to proclaim the Holt name in California and the world. A major street in Stockton is named Benjamin Holt Drive. Of particular interest to the University of the Pacific in Stockton was William Knox "Bill" Holt, who went on to graduate from the University of California at Berkeley and to organize a Caterpillar dealership, distributing tractors in Mexico and Europe. HOLT CAT, a successor company to the William K. Holt Machinery Company formed in 1933, is still based in San Antonio, Texas. Bill attended the 1976 dedication of the Holt-Atherton Pacific Center for Western Studies, later the Holt-Atherton Special Collections, at the University of the Pacific. The center was named for the longtime regent; her daughter, Anne Holt Atherton; and Anne's husband, Warren Atherton, "Father of the GI Bill."

Benjamin Dean Holt's son, B.D. Holt, lived with his grandmother when she moved to San Francisco. The younger Ben Holts took over the house at

548 Park Street in the early 1930s. For two years, 1937–39, B.D. attended grammar school while enjoying a spacious upscale apartment and meals prepared by a cook. When grandson and grandmother went out, they traveled in a large chauffeured car. Mrs. Holt didn't linger in San Francisco, moving after several years to the large house she built on Carmel's Scenic Drive—the first street parallel to the beach. The property included the dunes, which were overrun by all the grandchildren. B.D. remembers at least twelve of them enjoying the surf and the gorgeous home on the Pacific.

Anna would outlive Benjamin by thirty-two years. When she died in 1952 at the age of eighty-four, she was widely known for her social and charitable work as a community leader. The friends she made in Stockton were not forgotten, though she moved away from the dusty city and the inauspicious neighborhood that she so long called home to the picturesque area she must have dreamed of many times. A 1937 social note from the *Oakland Tribune* records Mrs. Holt ("of Stockton and San Francisco") entertaining members of the Stockton Club at an alfresco luncheon. The informal organization of forty-five Eastbay residents, all originally from the Stockton area, was accustomed to meeting and renewing acquaintances on the first Monday of each month.

One might say Anna Holt never really left Stockton behind. She continued as a Pacific regent until 1949, three years before her death. She is buried in the Holt family mausoleum at Stockton Rural Cemetery.

Harriet Chalmers Adams

International Explorer and Speaker

A nationally famous female American explorer and geographer was able to weave in a bit of relief at being alive when she spoke to her hometown "ladies" in May 1915. Harriet Chalmers Adams, whose adventures began when her father, Alexander, took her on tramps through the Sierras, up the coast and into Canada, credited a concern for her father's health with an escape from death on board the British ocean liner RMS *Lusitania*.

The intrepid explorer had her ticket in hand, ready to board the ship in New York for its May 1 sailing for Liverpool. But word arrived that her father, Alexander Chalmers of Stockton, was seriously ill. Harriet headed west, and the *Lusitania* sailed without her, to be torpedoed by a German U-boat on May 7, 1915, off Ireland, killing nearly two thousand people and souring the world on Germany; it also speeded the United States' entry into World War I.

The world traveler, who encountered headhunters and pythons as a matter of course, had canceled so late that her name remained on the passenger manifest, and she was reported as missing when the list was published. Finally contacted in Stockton at her parents' home, she reassured the *San Francisco Bulletin* on May 13 that she had been busy writing seventeen magazine articles.

Unfazed by the mix-up, she spoke to the Philomathean Club about her visit to Borneo's "bamboo Venice of the far east," Brunel, illustrating the lecture of Bornean life with 126 slides. "On the Fringes of Asia" was a typical talk given by Chalmers, who lectured in cities and towns across the

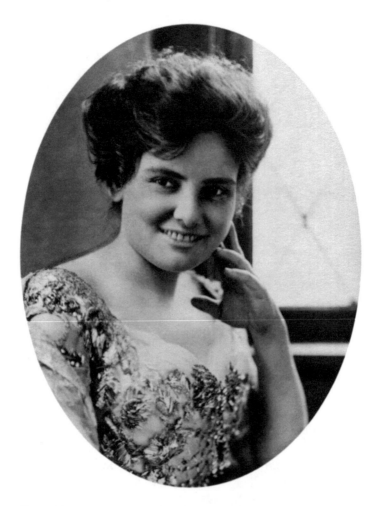

Harriet Chalmers Adams was a world traveler and *National Geographic* magazine author. *Courtesy of the San Joaquin County Historical Society & Museum.*

United States with her husband, Franklin. Founder of the Society of Women Geographers, she worked with the National Geographic Society for more than thirty years, and by 1907, when she first spoke at Stockton's Yosemite Theater, she had already published two articles in the magazine. The total would reach twenty-two.

The Stockton native, born in 1875, was noted for her groundbreaking visits to South America and the Andes, along with Haiti and the Dominican Republic. It was in late May 1913 that she sailed to Hawaii, then to the Philippines, Borneo, Singapore, Hong Kong and Shanghai. Adams was soon

off again to Europe after her Stockton visit, writing for *Harper's Magazine* as a war correspondent in France.

Harriet's career as a leading female geographer and explorer is credited to her father taking her on local adventures when she was but a child in Stockton. "There is no reason why a woman cannot go wherever a man goes—or further," she said in 1920. "If a woman be fond of travel, if she has love of the strange, the mysterious and the lost, there is nothing that will keep her at home."

Adams was plunked on a saddle when she was two years old and by age eight was horsebacking through valleys and along the coast, taking her far away from the usual pursuits of an 1880s young lady. Tea parties and dolls were replaced by trips with Dad, even up into the Rocky Mountains of Canada. Her mother, Frances, and sister, Anna, took more traditional journeys. Frances Wilkins was among the first settlers in El Dorado County, where she came with her father, Charles Wilkins of New Hampshire. The family arrived by overland trails and turned to merchandising when mining proved impractical for them. Alexander Chalmers was a Canadian. An engineer, he arrived to join his older brother, Robert, on the American River in Coloma. He moved to Stockton in 1868 to open a dry goods store and met Fannie; they wed in 1869. Chalmers Brothers Dry Goods and Carpets was located on El Dorado Street between Main and Weber Streets.

Her father took Harriet along on trips into Calaveras County, where he had mining interests. By the time she was fourteen, Alexander proposed a trip of the Sierra Nevada Mountain range from Oregon to Mexico. The Chalmers girls were educated at home by tutors, so school was not a factor in the decision. It was a year-long adventure in the saddle, beginning in 1889.

Already dreaming of further opportunities to travel, Harriet found a kindred spirit in Franklin Pierce Adams. Born in Napa in 1868, he was also from a pioneering family, his parents settling in Stockton in 1870. He was an electrician for the Stockton Gas and Electric Company when he and Harriet began courting. Some of their outings included sitting on the banks of the San Joaquin River, watching the ships sail in and out. They were married in Stockton in 1899 and postponed a honeymoon to save travel money while living in a local rooming house.

Their delayed honeymoon was in Mexico in 1900. As Frank's work would take him to various spots around the world, Harriet could often accompany him, but this was not always the case. In Mexico, Frank was on a mine engineering survey. Later, he joined the Pan American Union staff, serving from 1907 to 1934. They were often separated during her later travels.

Her mother's love of reading was passed to Harriet, who typically devoured enormous amounts of material before setting off on her explorations. Thus it was for their 1904 journey to Latin America. She read fifteen books on the area. She planned to follow the "trail of the conquistadors" and then write and lecture about the venture. The couple visited most of the countries on the continent, traveling by train, horse and boat. The entire length of Peru was explored, including Lake Titicaca, the highest lake on earth. Crossing more than one thousand miles in the Andes, they went by boat on the Amazon River and spent three months in the forest with the natives and what were then called Bosch Negroes, descendants from slaves. Many places she visited had never seen a white woman. The experiences could be terrifying. They spent one stormy night on a ledge with no sleep or food and later lost a horse and all their belongings.

For such activities, the petite (five feet, two inches) explorer chose pants, a man's shirt and other masculine wear. At one point in time, she insisted that one could preserve one's femininity in the wild; one of the items she had rescued from a treacherous river crossing was a jar of cold cream. Usually she packed riding and hiking boots, a warm coat for cold nights at high elevations, a split skirt for riding and gloves and hats. She claimed the cold cream kept her face from cracking in the highest Andes.

The couple returned to New York City in 1906 with a complete journal of the trip and three thousand photographs and motion pictures. She lectured the next year for the first time before the National Geographic Society. It was the beginning of a fruitful partnership. She and Frank were the first to use color photography in professional slide presentations, adding to the talk's allure.

By 1907, the couple was back in Stockton, speaking at the Yosemite Theater—which Frank once managed—to an overflow crowd. Frank was now working out of Washington, D.C., and Harriet gave a number of lectures sponsored by the Carnegie Lyceum, Pan American Union and Vassar Lecture Series. She was well paid, and one month she received $1,000 for a *National Geographic* article—more than her husband made that month.

Making her talks appealing to all ages was the fact that these were not mere "travelogues." She did not travel first class, and her aim was to make her audiences familiar with other cultures. Her focus was on customs, folklore and languages. She lived among the indigenous as she traveled, sleeping in huts or outside and eating native fare. Once, their bed was a dining room table.

She took part in the first Pan American Commercial Conference in Washington in February 1911, when she was introduced as "one of the most

experienced travelers and best lecturers" and gave the keynote speech. She continued to work for Pan-Americanism and to seek "intellectual bonds" between the women of North and South America.

One thing facing Harriet and other female explorers of her day was dismissal by male colleagues. She felt the need for the advancement of women in scientific professions. For instance, the Explorer's Club invited her to lecture but would not extend a membership. (The now international group did not admit women until 1981.) To counter what they called "the isolation of women of the exploring species," a group of women founded the Society of Woman Geographers in 1925. Harriet became the first president, serving until 1933.

The male-oriented "explorers" looked askance at her lack of a university education, and despite thirty-one years traveling the globe and being a member of the National Geographic Society lecture series, she was snubbed by the organization. A yearbook published on its first one hundred years did not feature Harriet. While she lectured and wrote many articles, she never published a book. Also, she was not academically trained as a geographer. The first doctorate in geography was awarded in 1907. A separate geography department was not created at the University of California–Berkeley until 1898. The university did not bestow a PhD until after 1923. Adams was admitted to the Royal Geographic Society of London and belonged to other geographic groups in South America.

Beginning in 1910, the couple visited Cuba, Haiti and the Dominican Republic, tracing Columbus's journey; the visit was marked by them bringing back five rare, odd little rodents, solenodons, for East Coast zoos. She hypothesized that Columbus was buried in San Domingo and claimed she held ashes from the grave there from the rare exhumation of his remains. In 2009, a forensic team compared DNA from bone fragments found in a Seville, Spain cathedral with DNA from Columbus's brother, also buried in the city. The mitochondrial DNA was a match.

Adams began a trip around the world right before World War I. Hong Kong, the Philippines, Central Asia and even Siberia were explored. After her stint in France as a war correspondent, she again lectured, sometimes six times a day, to raise money for the Allies. She and her sister, Anna, attended the coronation of Haile Selassie of Ethiopia.

Harriet's health was seriously compromised when she fell in the Balearic Isles, off Spain. Several vertebrae were crushed, and she was told she would never walk again. Recovering in the United States, she was soon "back in the saddle" with visits to the Middle East. In 1929, she visited twenty countries

in seven months. She wished to see every country that had been a possession of Spain or Portugal.

By automobile, oxcart, on foot, by train, Harriet Chalmers Adams traveled the world and faced raging rivers, Bengal tigers and head hunters and in South America alone ranged over 100,000 miles of wild terrain. On January 1, 1934, Frank retired, and the Adamses decided Spain, and the Mediterranean, was the area most suited for them. Their winters were in Spain, Yugoslavia or Athens; summers they journeyed through Europe or Asia Minor. Harriet became ill with a kidney inflammation, possibly first encountered in South America, and recuperated in Athens. They went to Nice, France, for the spring. It was in Nice that she died in July 1937.

The *New York Times* lionized her as "one of the half-dozen leading women explorers of the world" the day after her death. The Society of Women Geographers established a memorial endowment fund in her name to help society members continue research. Even in Stockton, where some of her scrapbooks are stored at Cesar Chavez Central Library, her name lives on. The Harriet Chalmers Adams Society annually celebrates her birthday on October 22. It raised money to install a bust of Chalmers on the library's staircase landing.

Dr. Margaret Smyth

Leader in National Mental Health

C ould people be driven mad by disappointment? A fixation on quick riches in the gold fields could lead to despair for many an unsuccessful Argonaut who had left everything to scramble into the Mother Lode hills and their mines. Discouraged and broke, might some have lost their way mentally? And as many others rushed into California in the early 1850s, might they bring depression with them and become mentally imbalanced in this wild new area?

By March 1851, the state legislature answered yes and passed a bill establishing the state hospital system. Sacramento State General Hospital would care for those injured in the Northern Mines, and Stockton's would take Southern Mines patients. Thirteen ill people were soon accepted into a wooden former saloon on the corner of El Dorado and Market Streets. They had been kept until then on a prison ship anchored in Stockton Slough.

The hospital soon became overcrowded. Stockton and Sacramento had sheltered those with mental health issues, as well as the physically ill and injured. Late in 1851, Sacramento had 34 disturbed patients and Stockton 13. By the next year, it was recommended by state officials that all mentally ill patients should have their own institution. They were to be sent to Stockton, where Dr. R.K. Reid was already treating 134 unbalanced individuals of both sexes. Treatment buildings ranged from Center to El Dorado Streets, and overflow patients were chained to oaks in the yard. In the first month of 1852, 403 people were admitted. The state decided a California General Hospital and Insane Asylum should be constructed to house at least 500.

Margaret Smyth became the nation's first woman to head a state hospital.
Courtesy of the Bank of Stockton Archives.

Emily Knoles

Building a University

Emily Knoles of Pacific, as she became known in Stockton and in the state education field, was a woman who could put dinner on the table for eight or eighty, wrangle a horse into submission, chair a meeting of hundreds of women and go out onto the University of the Pacific campus with encouragement for students and faculty alike.

Arriving in the city with her husband, Tully C. Knoles, with the newly relocated College of the Pacific, Emily also raised eight children and accompanied her loquacious husband on his many talks around the state and nation.

"She was the greatest first lady any college ever had," one biography reads. Her dedication to the university was celebrated, along with her 100th birthday, at Morris Chapel on campus on September 30, 1977. A poem written that year by Pearl Shaffer Sweet of Seal Beach summed up her work on campus and as a vital helpmate to her husband: "As a wife she bravely stood/Taking years both bad and good/In the home was calm retreat/…She ennobled gracious art/Loving, serving from the heart/…She helped Tully be his best."

The Knoles family proved a terrific asset to the community, as did the college, when all arrived in 1924. The institution became the Central Valley's first private four-year university. It was founded in Santa Clara in 1851 by Methodist ministers. Under the name California Wesleyan College, it became California's first private chartered institution of higher learning and changed its name to University of the Pacific. The name switched to

Emily Knoles was a university's beloved "mother" and helpmate to husband Tully. *Courtesy of Holt-Atherton Special Collections, University of the Pacific Library.*

College of the Pacific in 1911 and back to University of the Pacific in 1961. The liberal arts college portion of the university is still called College of the Pacific. Pacific started the first medical school in 1858 (now California Pacific Medical Center–San Francisco). The institution moved to San Jose in 1871, merging with Napa College in 1896.

Tully C. Knoles was an irrepressible administrator, pastor and public speaker. He began as president of the College of the Pacific in 1919 on the San Jose campus, and one of his major accomplishments was moving the campus to Stockton. He served as chancellor from 1946 to 1959.

The family of ten—all the children graduated from the college—settled in downtown Stockton while the college and the president's house were built. The stately president's house still houses university presidents and has been graciously modernized over the years. One thing lacking in the first years was a dishwasher, Emily laughed in an interview. "So when we had a large dinner—and with ten of us they started out large even before we added guests—all the children would help. Students would help too, sometimes."

Surprisingly to the community, the president and his wife also housed both their mothers. "They were firm friends," Emily recalls. They would listen to favorite radio programs each evening.

Emily was the daughter of Peter Walline, a Swedish immigrant, who settled in Cambridge, Illinois, but around 1895 moved the family, including Emily's two brothers and a sister, to North Ontario, California, when she was eighteen. Her mother didn't want to live in California because of earthquakes, and then one hit Illinois. "I guess we might as well go," she sighed. "We can't get away from them."

Peter Walline worked in a store, maintained orange groves and built a house on Euclid Avenue in Upland. (It was his suggestion, Emily said, that the community change the name of North Ontario to Upland in memory of Uppsala, Sweden.) Meanwhile, Tully's parents had also settled in the area from Petersburg, Illinois, and the two met, attending lectures, recitals, athletic events and concerts.

Soon they both moved to Los Angeles, boarding in the same home as they attended the University of Southern California. Enterprising Tully got a hauling job on the side to raise funds for an engagement ring. The two wed on August 23, 1899. He graduated from USC in 1903, by which time the couple had four children. Emily had given up her studies to marry, as many women routinely did in that era. At their marriage, she expected to be a preacher's wife, as Tully was an ordained Methodist minister. Throughout her life, she regretted being unable to receive her degree in history. Her wish for a degree was satisfied on her 100th birthday as Pacific president Stanley McCaffrey presented her with an honorary degree of doctor of humane letters for her "significant contribution to the progress and humanity of the university."

In his work at the university, indeed throughout his life, Tully was an accomplished public speaker. His most important audience was his wife. "She liked to hear him talk about horses and in fact she liked to hear him talk—period," recount his biographers. Apparently, Emily Knoles, who glares sternly through spectacles from a press clipping in the late 1930s as she assumed a presidency of two years of the leading women's group in town, the Philomathean Club, understood her husband's opinions on his many subjects of interest and adopted them as her own. Tully recognized her deft way with finances and let her make the monetary decisions. In 1902, the small church salary and fees for breaking horses that Tully received were saved up, and soon the couple had a down payment on an eight-room home in the Los Angeles area. (He broke and trained horses for years and is still remembered by some Stockton old-timers riding his horse downtown.)

Before coming to Pacific, Knoles was the head of the History Department at USC. En route to a YMCA (Young Men's Christian Association) convention in Monterey, he was hit by a mysterious illness that a doctor diagnosed as a strangulated hernia—until he opened him up and didn't find one. The Knoles family decided to move to Emily's father's cattle ranch in Inyo and Mono Counties. The acres of alfalfa, daily horseback riding, care of the cattle and camping in the hills pleased Tully to no end. The turkeys alone moved him to rhapsodize, "My wife was interested [in them]...she had a flock of fifty pure white ones. I think I have never seen a more beautiful sight than those white turkeys on the green alfalfa field."

Knoles never forgot to praise his wife as a life partner. Together they put a welcoming stamp on the new university. "It was...the attitude he reflected and the manner in which he and his wife lived, that had [the] greatest effect on the community," the biographers note.

Settling into unfamiliar territory, the young college had its struggling years, and Tully's outgoing nature helped. He became to some Mr. College of the Pacific, recognized for his personal stature of a learned professor and administrator, and a jolly good speaker and friend. Young faculty and their families were warmly welcomed. Tully and Emily became fixtures at Central Methodist Church and both enjoyed involvement in Rotary International. She attended district conferences and international conventions with him.

Success was not a given when Knoles began his work as administrator. The San Jose college competed for students with well-funded neighboring schools. Facilities needed an upgrade, and entrance requirements had been lowered. He began to toughen up admissions policies and look about for places to relocate. Only two faculty members declined to move to the forty-two-acre Stockton campus. In the new city, college finances improved along with enrollment. Degree presentation soared in the first decade. Six original buildings expanded to twenty-four and acreage to seventy-two.

The Great Depression brought a 30 percent enrollment drop, but Knoles established a coordinating committee in 1934 that helped keep the college afloat by recommending allowing high school students not fully qualified into a new lower-division program and for a remedial program for its own students who "failed to maintain satisfactory performance." Called the College of the Pacific Junior College, it enrolled seventy-three students in the 1934–35 school year. The Stockton Board of Education, then paying $30,000 a year to send students off to other junior colleges, took the program over in 1935 in partnership with Pacific, and it was renamed Stockton College. The university faculty taught courses under separate contracts, continuing

the partnership through World War II. Stockton College is now San Joaquin Delta College, serving over nineteen thousand students.

During the war, Knoles was successful in establishing the U.S. Navy's V-12 Program for accelerated pilot training. More than 545 men took part in the military training program in 1942–43, many returning after the war to finish their studies.

The couple remained in the campus home until 1946, when Tully became chancellor and served in that post, living in Stockton, until 1959, the year he died. All but one of their children entered the education field; they had thirteen grandchildren and twenty-five great-grandchildren at the time of Mrs. Knoles's death in Palo Alto on August 18, 1980. Both are buried at Park View Memorial Mausoleum in Stockton.

With this being the age of the homemaker and stay-at-home mothers, Emily put her children first. "Sometimes I think the reason they turned out to be good people is because I kept them under my thumb," she recalled late in life. "I guess I had kind of an iron hand."

She certainly left much of the publicizing of the university, the Methodist Church and other organizations to her husband—and he obliged. He spoke to the Philomathean Club when he first got to town in October 1924 on "The New Renaissance." The club called him one of its most popular speakers. He spoke to university gatherings and the Rotary Club, one of his major passions. He spoke to one and all, and he also delivered sermons. During World War II, he toured the Pacific Coast to boost Liberty and Victory Loan drives and was celebrated as an outstanding "four-minute" speaker."

His biography reveals that his "career as a public speaker" began as a young man. "He made but few notes," Reginald and Grace Stuart write in their book, *Tully Knoles of Pacific: Horseman, Teacher, Minister, College President, Traveler, and Public Speaker*, "and those only of the main subdivisions of his address. In his preparation, he considered thoughtfully each of the main topics and arranged in his mind a plan for their logical development. Then when he came before an audience, the brief notes suggested a subject and his mind automatically brought forth the reasoning and information necessary for its gradual evolution."

Tully simply loved to talk, and his audiences liked to listen. He spoke throughout the West, and ten days before his death, he was still speaking, this time to the California Junior College Government Association Convention at Oakland's Hotel Claremont. Knoles undoubtedly had something to say to the 540 admirers and family, including 10 grandchildren, who fêted him

with a banquet at Stockton Civic Memorial Auditorium on the occasion of his eightieth birthday in 1956. And could he have been muffled at his sixtieth wedding anniversary, celebrated with his wonderful lifelong partner right before his death, on August 27, 1959? One thinks not.

Elizabeth Humbargar

Fought Wartime Injustice

Horse stalls became their homes. Others were warehoused in "makeshift units"—275 people squeezed into twenty black tar paper shacks. Their businesses and their homes were sold at fire sale prices. Many ate their last meals "outside" at the Canton Low Restaurant downtown and other local restaurants. The next day, they brought what they could and showed up at the Stockton Fairgrounds, ominously transformed into the "Assembly Center" by the United States Army Corps of Engineers.

The date was early May 1942, and those county residents of Japanese descent were part of a mass detention of 112,000 on the West Coast. The county detainees numbered 4,484, less than 3 percent of the 154,000 population. President Franklin D. Roosevelt had ordered that "enemy aliens" in coastal areas be evacuated to the nation's interior. Over 127,000 Japanese were sent to concentration camps over fears they would remain loyal to their ancestral country. It was also assumed they would be a security risk. The Japanese attack on Pearl Harbor on December 7, 1941, had made everyone nervous, and we were now at war with Japan.

Almost two-thirds of the interns were Nisei, or Japanese Americans born in the United States. No Japanese were excepted. Veterans of the First World War entered the camps as well. Stockton Japanese entered the camp over several days. The first two hundred were taken on May 10, with thirty-one the following day. They were nurses, workmen, doctors and storekeepers. By May 12, nearly six hundred had been moved from the Stockton Armory. As they were called, there was no expression on their faces. The obedient people

Elizabeth Humbargar taught interned Japanese students and was there on their release. *Courtesy of Jim Veraga, San Joaquin Delta College.*

had even shown up well before the deadline. The *Stockton Record* announced on May 13, "No Japanese Left in Stockton as Nearly 1000 More Moved."

As for the children, they were interned with their families. Stockton Japanese American students attending the University of California–Berkeley, and the University of the Pacific were charged to report. So were students at Stockton High School. They were all to be detained, the Wartime Civil Control Agency decided. There was no thought of continuing the students'

education. For Stockton High attendees, this meant losing a semester of academic credit.

Teachers have a reputation of being a hard-nosed bunch, renowned for forcing education on the masses of reluctant students filling their classrooms. Elizabeth Humbargar and her sister, Catherine, couldn't see why learning had to stop in wartime. And they didn't think much of their students being pulled out of class, thrown behind barbed wire and guarded by armed men.

Unfortunately, the two had full-time jobs at Stockton High, so their options to teach at the Assembly Center were limited to two hours a day. But they found willing college students to organize classrooms. School authorities agreed to grant credit. The two began surreptitious raids on school district book warehouses. Daily, they visited the fairgrounds to train the young internee instructors. They obtained lesson plans and daily assignments from other Stockton High teachers.

As their daily visits continued—attended by catcallers at the gates accusing them of aiding the enemy—the two women fooled the guards into thinking they were pregnant. They were carrying contraband food, like salami, in for the students and their families. High school officials looked the other way as old textbooks and supplies left the building. Many were taken out to the camp by the janitor in his horse trailer. The sisters utilized the grandstands and an empty barn. They had tables made of sawhorses and planks. In time, they established a library of over one thousand books.

"Most of the kids couldn't believe they were there," Elizabeth recalled in a newspaper story many years later. She found students in shock during their first few days at the camp. Gradually, some sort of normalcy returned. The famous football legend Amos Alonzo Stagg, then coaching at the University of the Pacific, spoke at a Boy Scout event. Jack McFarland organized recreational programs. A former sports editor for the *Stockton Independent*, he organized games and activities for every age group from May to September 1942. And these teenagers relished their educations.

Often when Elizabeth Humbargar entered the classroom, located in a room above the cow barn, she would find a special "teacher's bouquet" on her "desk" of wooden boards. They were arrangements of dried grasses and wildflowers. She commented, "I have seen few bouquets since then of greater beauty or poignancy."

Elizabeth was intent on involving students in whom she saw promise, such as Barry Saiki. He had graduated from Stockton High and was the editor of *El Joaquin*, the Assembly Center's newspaper. He had been encouraged in public speaking by Ms. Humbargar. Now, he had been forced to leave

Berkeley without his expected diploma. Elizabeth urged him to teach drop-in classes in California history and current events. Through such efforts, 92 percent of the detained students received their semester's academic credit. The occasion was observed with a graduation ceremony.

The situation at the fairgrounds changed in the fall. Detainees learned they would be interned in Rohwer, Arkansas. Elizabeth and Catherine offered long-distance support. Later, the two wrote as many as five hundred recommendations for school admissions, scholarships, financial aid and jobs. The efforts were recognized by the government; federal agents investigated the activities and placed Elizabeth's name on a subversives list.

The Rohwer Relocation Center housed those from the West Coast. The cemetery is now the only lasting part and is a National Historic Landmark. It was one of the last of ten such camps nationwide to close. Rohwer, at its peak, housed 8,475 people. It sat on five hundred acres. The tar-papered, A-framed buildings were set in blocks, each block accommodating 300 people in ten to fourteen residential barracks. They were divided into four to six apartments. For each block there was a mess hall building, a recreational barrack, a laundry and a communal latrine. There was no plumbing or running water. Barbed wire enclosed the camp, and armed military staffed the guard towers.

Elizabeth, who taught English at Stockton High, and her sister, a math teacher, were the victims of prejudice themselves while growing up in Salina, Kansas. There was prejudice against Catholics in the area, and they were unsuccessful in obtaining work, so they moved on to find jobs in California. The sisters were of German descent and likely experienced intense anti-German sentiment during World War I as well.

Later, when many foreign students came to Stockton Junior College and University of the Pacific, Elizabeth organized an association (the Foreign Students Association) to protect their rights. "I had the privilege to serve as president one year," says Mel Corren, a retired Stockton businessman. A picture of Corren, Elizabeth Humbargar and association members hangs in the new counseling center on the San Joaquin Delta College campus.

The sisters lived with their mother, also named Elizabeth, on Country Club Boulevard, their backyard separated by a low brick fence from young Mel Corren and his family. Students were often their guests, Corren writes in his memoir, *I've Lived It, I've Loved It.* Elizabeth "offered what she could in the way of tutoring and support at the Delta College campus. She was an absolute humanitarian," Corren has said.

When she started teaching at Stockton High, she was the faculty advisor of the Japanese American student club, which numbered four hundred. The

Nikkei Club also received a visit from Amos Alonzo Stagg. She also helped out personally, as she and her sister took a student into their home each year. These guests usually lived far out in the country and could not reach the school easily. They spent the week with the sisters and the weekends at home. Japanese students arriving after the war to study here were also made welcome in the Country Club home. As early as 1936, she was chosen by the Japanese government as one of fifteen West Coast instructors to visit Japan, Korea and Manchuria.

The home on Country Club was utilized during the war by Nisei soldiers stationed as translators at a prisoner of war camp for Japanese nationals at Byron Hot Springs. These Military Intelligence Servicemen could travel the sixteen miles and relax together at the comfortable residence. After the war, the returning students and their families found the house open as a temporary hostel.

After the war, Elizabeth began teaching at Delta College. Her special interest was English as a second language. She was also a counselor. She wrote several handbooks and manuals on conversational English.

Gratitude began to flow in for the forty-four-year teacher, who retired in 1969. Former students presented her with one of the county's first television sets in 1949. A 1970 testimonial dinner raised $15,000 that was turned into a JACL (Japanese American Citizens League) scholarship. After the war, she helped restart the Stockton JACL. A tremendous honor came in 1978 from the emperor of Japan, who bestowed on Elizabeth the Order of the Sacred Treasure. JACL president Richard Tanaka escorted Elizabeth and Catherine to Tokyo. Barry Saiki hosted a banquet for them, with former students attending.

Her death in 1989 is not the end of the Humbargar story. In April 2012, the Stockton JACL arranged with Delta College that the new Elizabeth Humbargar Tolerance Garden be dedicated. Located behind the Lawrence and Alma DeRicco Student Services Building, the garden accompanies the refurbished nature trail of gardens and native trees. The garden is a tranquil gathering spot for students. The plaque reads, "Elizabeth Humbargar's steady gaze, iron will to fight injustice, and promise of a better future continued for all students until her retirement in 1969, and inspires us still today."

Wilhelmina Henry and Flora Mata

Breaking the Color Barrier

They lived simple lives, with simple pleasures, in simple homes. There was nothing ostentatious about the two Stockton women raising their children after World War II, seeing that their religious faiths were handed down, their love of learning passed along to the young ones.

And yet these two women revolutionized the Stockton schools. As lifelong teachers, they shaped thousands of young minds with their own prestigious educations and philosophies of equality. They broke the color barrier in the Stockton Unified School District. Wilhelmina Henry became the district's first African American teacher in 1947, and the next year, Flora Mata was hired as the first Asian American instructor. They opened the way for innumerable minority teachers and set an example for their multicultural students who could now aspire to teaching careers.

Wilhelmina had been teaching for years in South Carolina and Georgia when she arrived in Stockton with her first husband, Ruben Smith, in 1946. The following year, she decided to apply for a teaching position, well aware that no other African Americans had ever been allowed in that position. "There was a lot of rigmarole," she laughs, now ninety-three and living in the same home she purchased years ago in a modest section of Stockton. Of all the instructors who took the teaching test, she got the highest score. She also credits Lula Parker and the California Council of Negro Women with helping her obtain the position. (The council was founded in 1935 by Mary McLeod Bethune, who advocated "womanpower among our women," calling for wider opportunities for black women and their families.)

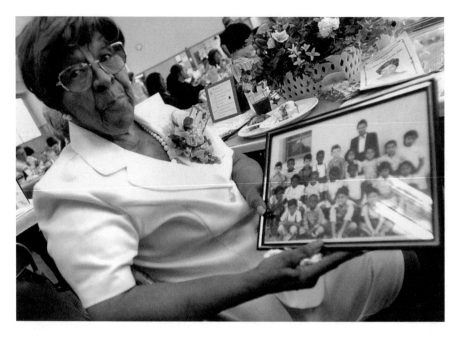

Wilhelmina Henry, first African American Stockton teacher, holds a photo of her first class, circa 1948. *Courtesy of the* Record. *Photo taken by Michael McCollum.*

Today on her dining room table is a picture of her and her first class at old Monroe School with a train they fashioned from large boxes. The first-grade class, like her other classes ("I ended up teaching fifth grade"), was composed "of all the races, as far as I could tell." Old Monroe was located at 135 South Monroe Street, at the corner of Washington. It opened in 1903 and was closed in 1967.

Flora Mata had been discouraged from trying to obtain a teaching job in the United States. She and her husband, Vidal Mata, graduated from the University of California–Los Angeles, but a dean warned that because of their ethnicity, finding work would be impossible in the state. He suggested Hawaii, which had not yet been admitted into the American union. Flora had a question for him. "Why is it that America would educate the minority and not give them an opportunity to use this education?" she questioned. "Why is it that they need a college education to be dishwashers?"

The Matas first lived in the Philippines and then returned to Stockton after World War II. Answering an advertisement in the *Stockton Record* for substitute teachers, Flora was urged by the person on the phone, "You must come in—you don't sound like a minority." She told the newspaper near the

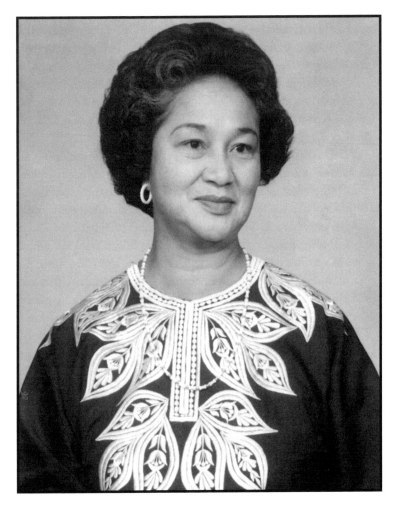

The first Asian American to teach in Stockton schools, Flora Mata was advised to seek a teaching post in Hawaii. *Courtesy of the Mata family.*

end of her career that she was hired as a substitute and the next year taught full-time kindergarten classes. "They seemed to think there would be less prejudice with little ones than with older students," she commented.

Both women went on to long and fruitful careers. Wilhelmina had a school named for her. The Stockton Unified's Black Employees Association campaigned for that, and the campus opened in August 2006. Very touched by the honor, Mrs. Henry was "blessed beyond words" by the whole thing and goes to each year's graduation honors. The facility is located at 1107 South Wagner Avenue.

Wilhelmina Henry was born and reared in Columbia, South Carolina, to a mother, Wilhelmina Ancrum, who had graduated from Allen University in 1905 and went on to teach in Columbia schools. Her father was a fireman on the railroad, shoveling coal. To this day, she calls it a "blessing," as the family was able to ride the train for free. She graduated from Booker T. Washington High School in 1936 and was sent to what was then called the Tuskegee Normal and Industrial Institute, founded by Washington. The pioneering educator hired George Washington Carver, who was also a scientist, botanist and inventor. Wilhelmina saw Dr. Carver on campus from 1936 to 1940 and recalls school assemblies arranged around his many inventions. Carver, thought to be born a slave in Missouri in 1864, had a museum built in his honor at Tuskegee. Mrs. Henry recalls his fondness for comfortable clothes. "We would see him walking around in those baggy clothes," she recalls. "He wasn't concerned about his clothes at all."

She began teaching in Columbia when she met her first husband at a USO show. She and Ruben Smith eventually married and came to Stockton. Her second husband was the Reverend Edwin T. Henry. Her grandson Edwin T. Henry III lives with her. Her daughter, Rachelle Mimms, caught the teaching bug (Wilhelmina's three sisters taught as well) and instructs at Commodore Stockton Skills School. Another son, Ruben Smith III, is a graphic artist. She has five grandchildren and three great-grandchildren and humorously despairs of the ones who haven't gone into education: "Oh, this latest generation!"

Sheree Mata teaches kindergarten at Lincoln Elementary School and recalls her grandmother, Flora Arca Mata, as "fun, loving and witty. She always had words of wisdom. Education has just been a part of our family." Born in Hawaii in 1917, the longtime teacher moved to the Little Manila section of Stockton in the early 1920s. Little Manila was a thirty-block center of Filipino American life from the 1920s up until it was razed by developers in the 1950s and 1960s. Many Filipinos seeking work in America came to the fields of the Central Valley. "By the 1920s, this was the heart of Filipino America. You have almost 100,000 living on the West Coast on the eve of World War II," points out Dr. Dawn Mabalon, a Stockton native and now associate professor of history at San Francisco State University. The asparagus season would bring up to 15,000 Filipinos to town. They lived in single resident–occupancy hotels in Stockton. Mabalon didn't forget her old neighborhood. She helped found the Little Manila Foundation, which saved three buildings and got the area designated as a historic site. Hopes now are for a museum in one of the rescued buildings.

Flora attended Stockton schools. An older sister paid her tuition to UCLA; the sister worked in Stockton's fields alongside other Filipino workers. As a fun aside, the couple worked for the family who owned Campbell's soup and for actor Boris Karloff. Vidal was Karloff's chauffeur. Sheree says the Karloffs knew what hard work was and welcomed the young couple with open arms, giving them shelter as well. "They were very gracious," she says.

The Matas were very religious and had two children, Eddie Mata and Vida Mata-Langley, an adopted Korean American. Now there are eleven grandchildren, nine great-grandchildren and one great-great-grandchild.

Flora taught at McKinley School the longest and also at Kennedy and Martin Luther King Schools. It was unusual for minorities to be sent to north Stockton schools (in newer, more affluent areas), it was pointed out in her obituary, but Mrs. Mata was not bitter. "My mother imbedded in us that you cannot hold hate," Sheree says. "My mother always said, 'If you want to change the thinking of people, go into the classroom.'"

Flora was too involved in her children's and grandchildren's lives to brood on past hurts. She attended innumerable school and social activities and continued to substitute teach until her eighties. She also volunteered in Sheree's kindergarten class. She continued an active life—she died in September 2013 at age ninety-five—jumping rope until she was eighty-five and playing tennis with her husband well into her eighties. She told her children and grandchildren, "Remember where you came from! And go as far as you can go."

Wilhelmina Henry estimates she taught for fifty years before retiring at age seventy. Colleagues joined former students, friends and relatives when the Wilhelmina Henry Elementary School was dedicated by the California Retired Teachers Association. She became the "matriarch" of all the teachers and knew students' families and home situations. One of the ones "in dutch" with Mrs. Henry was Alfred E. Smith, who became a pastor. He came to the ceremony and commented, "I'm thankful that she asked me to leave her classroom." Also, he had to bring his mother in for a conference. Rather than getting in more trouble, Smith learned that he was to be advanced to an accelerated program. "You set me on the course. I appreciate that you would look at this little student."

Indeed, Mrs. Henry admits the hardest part of it all wasn't breaking the color barrier, being a trailblazer and/or acting as a role model. "I was a tough teacher," she laughs, "and I had to make those children write lots and lots of sentences" (i.e., "I will not talk in class"), she explains.

She still enjoys her home and yard and finds a special outlet in a black sorority, Alpha Kappa Alpha. Its Stockton chapter, Mu Zeta Omega, was formed in 1978. Alpha Kappa Alpha was formed in 1908 at Howard University.

The Stockton School District operated under a court-ordered desegregation plan for five years. (It is noteworthy that black students first graduated from Stockton High School in 1896.) The suit, *Hernandez v. the Board of Education of Stockton*, was filed in 1970. The trial ruled in 1975 that racial imbalance existed in the student population of twenty-six of the thirty elementary schools. Four out of five junior high schools and two of three senior high schools also were cited by the court. "The schools in the north of Stockton were racially identifiable as 'Anglo' schools and those in the south were identifiable as minority schools," the court found. Segregation was discovered in staff and faculty of these schools as well. The court commanded the district to adopt and implement an integration plan in 1978.

The court ruled in 2003 that "all vestiges of intentional segregation" had been eradicated and lifted the court order. Now the Student Assignment Plan focuses on ensuring diversity, giving attention to minority group isolation among student populations at some schools. It was recommended in a 2013 meeting that the board adopt the "Voluntary Integration Plan to Reduce, Eliminate or Prevent Minority Group Isolation."

Joan Darrah

Strong Mayor Leaves a Legacy

In the late 1980s, Stockton City Council meetings were widely labeled the "Monday Night Circus." The mayor was finally forced to resign because of falsifying travel vouchers; his chief opponent, eccentric and profane, was eventually voted out and spent nearly four years contesting the race. Then there was the homeless woman with a lot to say—much of it ranting at any civic body that would lend her a microphone.

It was into this milieu that Joan Darrah, a teacher, Junior Aid leader and political novice, stepped gingerly after her own election to mayor in 1990. She entered the fray with the initial goal of settling down the fractious body and bringing decorum back to city hall.

She succeeded and went on to reduce crime, start the reconstruction of downtown and write a book about it all, *Getting Political: Stories of a Woman Mayor.* Longtime senator Dianne Feinstein wrote in the introduction, "Hers is a story of diligence, perseverance, and patience as she thrust herself into the conservative and male-dominated politics of Stockton."

Her widower, retired Superior Court judge James Darrah, says her greatest contribution may be taming that very contentious city council so that work could begin on Stockton's transformation from a crime- and drug-ridden city with a disintegrating downtown area. The work she began on waterfront renewal was a process that continued into the next several administrations. "You need to carry beyond your own term," Darrah notes. Added the succeeding mayor, Gary Podesto, "She's probably responsible for the biggest turnaround in Stockton."

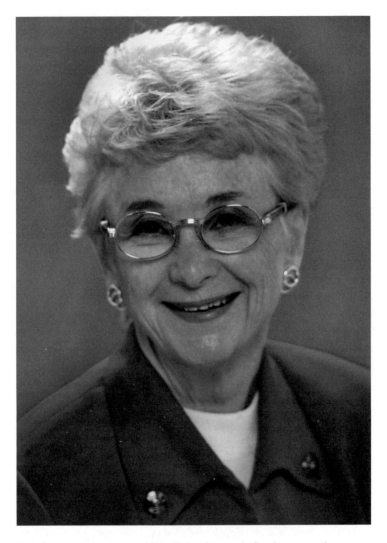

Joan Darrah had run for public office only once before but was twice elected Stockton's mayor. *Courtesy of the Darrah family.*

Darrah and the council began construction of the Weber Point Events Center and hired more than 150 additional police officers. She was behind Measure C to change the city council election procedure. It was passed in 1986 and replaced district-only votes with citywide in the final process. Now the two top district candidates would face a citywide election in November and compete for votes of all residents. She started the '90s with new council members elected under this measure.

Joan Darrah had run for office only once before, for the San Joaquin County Board of Supervisors, in the late 1970s. She was a Southern Californian by birth who spent two years at Radcliffe, then a liberal arts women's college in Cambridge, Massachusetts, finishing up at the University of California–Berkeley, majoring in political science. She taught at a public school in Los Angeles and then went to Stanford University to work on a master's degree in education and a credential in counseling. There she met Jim Darrah, son of former district attorney Guard Darrah and his wife, Lois, who lived in the Stockton-Lodi area. The couple moved to Stockton in 1961, where Jim Darrah worked with his father and served as his campaign manager for his run for state assembly. He lost, but the stage was set for politics.

Jim Darrah was elected to the San Joaquin Delta College board of trustees (1963–70) and in 1969 waged a campaign for judge on the county Superior Court. Darrah planned to run as a write-in candidate, but there was a chance to get five thousand signatures that would put his name on the ballot. "Of course Joan had the answer," Darrah laughs. "I was asking her, 'How do you get five thousand signatures in short order?' And she said, 'Jim, we'll have two big parties.'" One was to hand out petitions to their friends to get signatures; one was to have them bring the signatures back.

The petition was turned down, but publicity in the local newspaper, the *Record*, proved invaluable to the relatively unknown candidate. He became the youngest elected judge in California, and at thirty-seven, his salary was doubled and the family went to Disneyland to celebrate.

The experience was a positive one, and when Joan decided to run for the board of supervisors, turnabout was fair play. "Given the conventional, middle-class expectations of the 1960s, his supportive attitude was surprising," she writes. Says Darrah, "Why wouldn't I support her? She supported me." Joan had a formidable opponent in Doug Wilhoit. She campaigned hard, and the family was behind her all the way—even going grocery shopping. The three children each had a list and would set off in their searches. The newspaper got wind of it all, and the day before the election, a front-page article showed the man of the house taking the kids shopping. "Jim is 'the judge' and I am 'Joan,'" she recalled. Many thought she had forgotten "her place." The story of the judge who went shopping, Joan believed, cost her the election. "The next time I run for something, you keep a low profile," the judge was told. "Actually, I rather liked cooking and grocery shopping," he says. He took over cooking and household work during her mayoral years and, after he retired in 1993, offered to share the work with her. "You just keep it up," she told him.

Over the years, Joan had joined community boards and took courses at the University of the Pacific in the education doctoral program. Later, she served on the university's board of regents. She became active in Junior Aid, a women's philanthropic group that raised up to $60,000 a year for various civic groups. She was asked to join the board of United Way of San Joaquin County and served as its first female president. She began fundraising for Patrick Johnston when he ran for state assembly and worked with the Women's Center of San Joaquin County when it was offered a United Way grant to start a shelter.

Finally, Joan Darrah Public Relations was born, and she worked out of her home office. Her clients included the Stockton Civic Theater, San Joaquin General Hospital and the San Joaquin County Historical Society & Museum. However fascinating and successful the business was, Joan did not want to grow her firm. She realized she was waiting to run for public office again. Two other members of the small group who sponsored Measure C called and urged her to run—"I decided to go for it."

Her long involvement with and presidency of Junior Aid led to a friendship with Elizabeth Rea, who helped her fundraising efforts. Her own proficiency at organizing large social gatherings ("a professional fundraiser," she would say) saw her through the financial side of a busy and demanding mayoral run with the slogan, "Change for the better." She took an early lead over opponent Al Bonner and ended with 58.2 percent.

After a fabulous public inauguration party, she took a look at the mayor's office. It came up wanting. A refurbishment, albeit allowed by the city, was criticized, but Joan found it just the place she wanted to spend her next six years.

She found one of her chief difficulties was the city manager, who had the habit of yawning "and then blow[ing] his foul-smelling breath right smack into my face." She relegated him to a table in front of the council dais but at a lower level. "He was an employee of the council and the city of Stockton. He could damn well sit where we told him to." The recalcitrant city manager soon resigned, perhaps sensing he would be fired.

Perhaps no one ruffled Joan Darrah's gracious demeanor more than Thi To Can Nguyen. A well-educated immigrant from Vietnam, Mrs. Nguyen created mayhem with her disordered comments at city council, board of supervisors and civil service commission meetings. "Mrs. Nguyen became the wayward celebrity of my political career," the mayor recalled. She came to Darrah's first council session and was present at almost all of them for the next seven years. The insults, harangues and interruptions continued

until the city attorney suggested the five-minute speaking rule. Darrah had to turn off Nguyen's microphone at one meeting and ask the police to eject her. Finally, charged with an attack on another woman at the Tuxedo Street Post Office, where she slept, Nguyen was jailed for sixty days. There is now a new ordinance regulating disruptive behavior. Nguyen still walks city hall corridors and does much of her photocopying at the Chavez Central Library across Martin Luther King Jr. Park.

Joan's proudest achievement was the reduction in crime. She found the Stockton statistics "nothing short of terrific," as every year the crime rate decreased. The city compared favorably to California as a whole by 1997, a result of the utility tax to pay for more police and community/police collaboration initiated during her terms.

Her second run for the office was a nail-biter. She was ahead by only 24 votes when she went to bed at 11:00 p.m. Her opponent was boasting of the success of his own (monetarily) tight campaign, and the *Record*'s first edition showed him beaming with joy. She won by a little over 1,300 votes.

It was after an invitation to a Mayors' Institute on City Design, hosted by the National Endowment of the Arts, that her second big accomplishment was born: downtown revival. She was one of seven mayors in the nation invited to San Antonio, Texas, in 1994 to bring a city design problem to urban planners and experts. Joan discussed it with the city manager, and staff came up with "The Channel Study." The document questioned what to do with the channel that contained historic Weber Point and the surrounding area. On her return to Stockton, she appointed a task force to study the waterfront development. Eventually, the "Stockton Waterfront Revival Vision and Action Plan" involved community input through public workshops.

In 1996, three months before she left office, the council established a continuing waterfront committee with the new mayor, Gary Podesto, and approved a $4 million expanded project. In October, ground was broken for the Weber Point Events Center. Described as a "start downtown attraction," the space is rented through the year for festivals, celebrations and concerts. A water feature and children's play area are popular. There is also a picnic site. Most dramatic is the fabric shade structure over the stage.

Darrah was urged by Democrats both local and in Washington, D.C., to run for Congress against Richard Pombo in the late 1990s but decided against it. She considered her earlier public service work as a natural entrée into local politics and received a sense of accomplishment from her council years. She was content to retire, enjoy her grandchildren and continue

to serve on Planned Parenthood Mar Monte and the Jacoby Center for Community and Regional Studies at University of the Pacific.

Right before her death in 2007, at the age of seventy-two, Darrah learned that the council was going to name a waterfront promenade in her honor. The Joan Darrah Promenade is part of the renovated Stockton Marina. When notified, her final quote for the press was, "Wow, that's big time."

Dolores Huerta

Crusader for Human Rights

No one had seen anything like it in Stockton—or in the rest of the Central Valley. Seventy people left Delano, California, on St. Patrick's Day 1966, determined to walk to Sacramento, the state capital, by Easter Sunday. Cesar Chavez was inspired by southern civil rights workers and figured, correctly, that a 246-mile "pilgrimage" would cast awareness on the long strike against grape growers.

It is impossible to know if more people in the San Joaquin Valley were shocked by the idea of a union for field workers or of a woman leading men in a full-scale labor movement. But soon, because of the leadership of Chavez and Dolores Huerta, both would become realities.

The National Farm Workers Association (NFWA), formed in 1962, utilized the effective tactics such as nonviolence used by African Americans to highlight discrimination in the South. The farmworkers' march, trailing up Highway 99 through Visalia, Madera, Merced and Manteca, was a major curiosity for the small valley towns. By the time the group entered Stockton on April 3, 550 people had joined the march and were welcomed with an enthusiastic crowd, 5,000 at one estimate, throwing flowers and offering money and food.

On his blistered feet and swollen legs, Chavez led the group on a three-block candlelight procession from Washington Park, their unofficial "overnight headquarters." They carried a tapestry of the Virgin of Guadalupe decorated with rosary beads pinned on with NFWA pins. They had stopped for lunch at Airport Way and French Camp Road and, after a Mass the next

The co-founder of the Farm Workers Union, Dolores Huerta has never stopped speaking up for field workers' rights. *Courtesy of the Bancroft Library, University of California–Berkeley.*

day at St. Mary's Catholic Church, trooped on to Sacramento. "This is the best reception we've had anywhere," a forty-nine-year-old laborer, Bill Price, told the local newspaper.

The sensational march was a triumph, and ten thousand trooped into Sacramento. And there they found Dolores Huerta, usually in the thick of things. However, the labor leader and activist, a longtime Stockton resident, had been asked to skip the march and keep the picket lines going with many of the other women of the movement. She joined the Sacramento rally with tremendous news: a contract with one of two of the largest companies involved in the Delano grape-growing industry had been reached under her leadership. Huerta, the woman who stayed behind, had negotiated a contract with the Schenley Wine Company, marking the first time in the nation farmworkers had arranged a collective bargaining agreement with an agricultural company.

Huerta was a familiar face to the farmworkers. The group was the predecessor to the United Farm Workers Union, formed in 1965, with

Huerta serving as vice-president until 1999. For the five years the Delano Grape Strike, called "La Huelga," had been going on, she had been termed "La Madre de la Huelga," or "The Mother of the Strike."

While she missed the first big march, there would be marches enough to come, including one in honor of Chavez, who died in 1993 in Arizona. She led a re-creation of the noted Sacramento march in 1994 from Delano to the capital.

A dedicated negotiator and activist, Dolores Huerta today lives in Bakersfield and in 2012 was awarded one of the nation's highest honors, the Presidential Medal of Freedom. She led a consumer boycott that resulted in the establishment of the California Agricultural Labor Relations Act of 1975, allowing farmworkers to form unions. She lobbied for amnesty for longtime farmworkers; that resulted in the federal Immigration Act of 1985.

The life of Dolores Clara Fernandez Huerta has been a struggle to do the right thing for those less fortunate, particularly farmworkers and other disadvantaged individuals. She was arrested more than twenty-two times and was severely beaten by San Francisco police. With her eleven children, she endured poverty as she devoted herself to union work. She was born in New Mexico to Juan and Alicia Chavez Fernandez. Her father worked as a coal miner but made extra money as a migrant farmworker. Years later, he was a New Mexico legislator. After her parents' divorce, Dolores and her two brothers moved to Stockton. Eventually, her mother purchased a restaurant, the Delta Café, and the sixty-bed Richards Hotel at 18 South El Dorado Street. She also owned the Angeles Hotel.

All the children worked and lived in the Richards, her sister Alice Arong of Stockton recalls. The hotel was centered around "the transits," as they called them—farmworkers. "My mother was a feminist before we knew the meaning of the word," she says. She died at only fifty-one but supported Dolores in her union activities and joined the Community Service Organization's group she founded here.

By the time she finished at Stockton High School, Dolores had encountered several instances of community racism, including the beating of her brother who ventured out to meet friends in a "zoot suit." The uniquely styled suit was favored by many young minorities, especially Mexicans, during and after World War II. She quickly married and divorced and continued to study at Delta College, then administrated by College of the Pacific, which she also attended. She began teaching in a rural area whose students affected her. "I couldn't stand seeing farmworker children come to class hungry and in need of shoes," she recalled.

Dolores soon connected with Fred Ross, who also wanted to improve the lives of field workers and had founded the Community Service Organization (CSO) in 1948. The two met in Fresno, and Dolores started a drive for voter registrations. She also founded a CSO in Stockton. Two years later, she met Cesar Chavez, who became a CSO volunteer through the San Jose chapter. After organizing the Agricultural Workers Association (AWA), she encountered sexism as well. Priests told her to go home and raise her family. Agreeing was her husband, Ventura Huerta. They divorced, and Huerta drew in family to help with the children; there were seven of them now. She drove nearly daily from Stockton to Sacramento (one hundred miles round trip) to lobby for farmworker interests.

When the CSO voted against forming a union, Chavez quit the group and moved to Delano. He encouraged Dolores to locate potential union members, so she and her children visited farmworker homes and farms. Finally, she also quit the CSO, moved to Delano and, very short of funds, moved in with Chavez and his wife, Helen. With her seven children and her hosts' eight, the house was full. Eventually, she was able to move to her own place, and within several years, the union had one thousand members. The two leaders could now collect a pittance, fifty dollars a week, from the union.

For decades, large landowners manipulated the Mexican, Filipino and immigrant workers to undercut one another and thereby lower wages for all. But Chavez and Huerta's example and leadership started the end of that "divide and conquer" tactic by, eventually, uniting all groups to stand together.

The grape strike came about when local workers were outraged by a wage cut in the Coachella Valley. Pickers from Mexico could come in to work the harvest, but the guest workers could never be paid more than local workers. The foreign pickers were being paid $1.25 an hour. The growers quickly cut local worker wages so they could pay both groups less. It was the Filipinos in the fields, members of the Agricultural Workers Organizing Committee, who first struck. The growers dropped the price cut, and the workers returned. Later, when arriving in Delano for the harvest, workers asked for $1.25 and the right to unionize. The growers refused, and the Filipinos walked.

The group's leader, Larry Itliong, was a friend of Huerta's, as he had helped her form the all-Filipino AWA. It wasn't long before the NFWA, predominantly Mexican, stepped in to assist the small, struggling union. On September 16, 1965, Mexico's Independence Day, more than five thousand workers left the fields. The union decided in 1967 to use a nationwide grape boycott to drive home its point and involve those far from the cities. Huerta got on the union's school bus with her children, forty farmworkers and ten

student volunteers to drive to New York City. There she set up protests and rallies to underscore the boycott. The boycott strategy worked, as millions stopped eating table grapes. Sales in major cities fell to 20 percent of past years by 1968. An estimated $4 million in grapes rotted in the fields. The strike and boycott ended in 1970 with a three-year union contract calling for higher wages, health benefits and even retirement plans.

By the 1970s, Dolores was embracing feminist causes. She helped found the Coalition for Labor Union Women to encourage women for greater involvement and spoke to the National Organization for Women. She was given *Ms. Magazine*'s "Woman of the Year" award and the *Ladies Home Journal*'s "100 Most Important Women of the 20th Century" honor in 1998. She was added to the National Women's Hall of Fame in 1993.

She also spoke out about the dangers of pesticides, especially to field workers. It was while protesting outside a hotel where then-president George H.W. Bush was speaking that San Francisco police beat her with a baton. Six ribs were broken, and her spleen had to be removed. She put union work on the back burner to focus on women's rights, traveling cross-country to encourage Latinas to run for office. Although sidelined in 2000 by health issues, Huerta led a march from Bakersfield to Sacramento to support a farmworkers' bill that was later signed.

When she received a $100,000 grant as part of the Nation/Puffin Award for Creative Citizenship, she founded the Dolores Huerta Foundation in Bakersfield. The group seeks to create leadership opportunities, including community organizing, and has as its priorities health and environment, education and youth development and economic development.

The farmworkers' movement continues to be an important one in Stockton. An elementary school located at 1644 South Lincoln Street bears her name, one of several around the country. The downtown main public library is named for Cesar Estrada Chavez. Huerta celebrated her seventy-third birthday at Huerta School in 2003, commenting, "This is one of the best birthday presents I've ever had in my life." She was there for the school's opening in 2002 as well.

She still continues speech-making, lobbying and community involvement. She is a board member of the Fund for the Feminist Majority. The honors are piling up as she enters her ninth decade. In the spring of 2013, she was inducted into the California Hall of Fame for her lifelong work for labor and community leadership. The Museum of California established the honor in 2006. As recently as the fall of 2013, she spoke out for Hispanic Heritage Month, commenting that "we have a long road to travel despite all our

achievements…a long way still to go in terms of our numbers compared with our representation." Her current concerns are plans for voter identification laws in several states, something she sees as a way to keep African Americans and Hispanics away from the polls: "There are still a lot of [white] people… who have learned nothing about diversity and inclusion," despite many regions where Hispanics make up as much as 50 percent of the population.

Sylvia Sun Minnick

Too Tough to Quit Loving

It has been a life of contrasts for Sylvia Sun Minnick. She was born to an aristocratic consular father who abandoned her when the Japanese invaded Kuala Lumpur during World War II. Handed over to the doctor who delivered her, she was dragged along into the mountains as everyone fled and later was given to another couple. Her earliest memories? "I know that I had been with masses of people running away when bombs drop. I was a refugee."

At age six, she rejoined her family in Manila, Philippines. The tiny girl with a Dutch boy haircut soon discovered that her Chinese father held a strange hatred for her. She was beaten, locked in closets, kicked and generally mistreated by the man who held the post of the first secretary of the new Chinese Legation. He and his glamorous wife coddled their two older children, but Sylvia lived like Cinderella, even after moving to a former prince's palace in Bangkok, Thailand. The waif's luck changed in 1951 when her maternal grandmother visited from California and offered to raise her. "Mother told grandma that she feared father would really think about killing me one day," she chillingly writes in her new memoir. The thought of going to America was subordinate to her delight at leaving the family home, whatever its wealth and prestige.

She was confused when her father called her in for a goodbye chat. "I want to give you something to remember me by," he said and struck her so forcefully that she crashed into his desk. She left the estate with a swollen lip, a black eye and a chipped tooth.

Author, politician and historian Sylvia Sun Minnick overcame great obstacles but never burned a bridge. *Courtesy of Sylvia Sun Minnick.*

Such treatment stiffened the young girl's psyche rather than destroying it. With such a background, was it any wonder that, years later as the first Asian on the Stockton City Council, she was able to weather—if not easily—what she perceived as subtle racism and the sensation of being "odd man out"? Sylvia had much experience as the black sheep, the one left behind, the one not wanted. She shook off the hurt and went to work for her constituents, and they elected her to two terms.

In fact, Sylvia Sun Minnick has never stopped loving her fellow man and attempted again and again to establish a relationship with her family, as she records in her autobiography, *Never a Burnt Bridge*. She went on to graduate with honors from California State University–Sacramento, to earn a master's degree there and to enter state government employment. She was twice appointed to state administration positions and authored a groundbreaking book on Stockton's Chinese. She is beloved in the Stockton Chinese community and has collected friends and colleagues everywhere she goes.

"I think there are some messages in my book," Minnick told a newspaper columnist. "Don't whine. Don't ask for handouts. Fight back, nicely. I do. I fight back, nicely."

At a 2013 dinner at the San Joaquin County Historical Society, she was lauded by longtime pal Robert Shellenberger, former county assessor and a local historian, as "a California girl with a great California background." Sylvia jumped in with both feet to a new and invigorating life on California soil, arriving in San Francisco on October 12, 1951, Columbus Day. She is delighted they have the same anniversary date. She tends to divide her life into "chapters"; this was the beginning of her Chinese American life. She and her grandmother lived in a Powell Street apartment, and Sylvia joined a lively Chinese American community and family.

She discovered she had a long California heritage. Her grandmother was born Lee Gum Ching in Oakland in 1889. By 1908, she had married Tom Foon Chew and had a child. Chew entered the canning business started by his father, Yen Chew. Precita Cannery in San Francisco was destroyed in the 1906 earthquake. Tom moved the plant to Alviso, renaming it Bayside Cannery. Canneries were also built in Mayfield and Isleton. He became known as the "Asparagus King" and took time to cultivate the delicate white asparagus grown on San Joaquin Delta islands.

Sylvia's senior year at Lowell High School brought unexpected tension back into her life. Her parents moved to the city as her father became the Republic of China's consul general to San Francisco and took a fashionable

apartment in Nob Hill's Stanford Court. For appearances' sake, she had to move back into the house. However, her father never hit her again. When he forbid her to attend college (a sister was at Dominican College in San Rafael) even though it was local (Lone Mountain College for Women), she ran away. The Federal Bureau of Investigation was involved because of her father's position. Regaining some control over her life, she applied to a print shop in San Mateo and eventually became self-sufficient. She attempted a parental reconciliation on their twenty-fifth wedding anniversary, but her gift was returned. Late in the same year, she married Don Chan.

The couple and their new daughter moved to Stockton primarily because of affordable housing considerations in 1961, and soon another daughter was born. "We moved into 4838 Claremont Avenue...my first real home." And so began another chapter. She began to settle into the unfamiliar community and, during her second daughter's birth, ended up in the same room as Ruth Weaver: "It was going to be a small world; some thirty years later, Ruth's husband, Floyd Weaver, and I served together on the Stockton City Council."

Sylvia eventually had the itch to continue her education. She signed up for one evening course at San Joaquin Delta College, studying English literature. As time went along, the couple divorced, and Sylvia began work as a junior stenographer with the State Division of Highways in 1965. She moved on to Deuel Vocational Institution in Tracy, a state prison. By the time she married Richard Minnick in 1974, her future, which often looked tenuous finance-wise, was set. She was now a member of the California Public Employees Retirement System.

The Minnicks met through work and the California State Employees Association. The family moved to the corner of Commerce and Willow Streets in a 1905 Craftsman house—"our milestone home," she calls it. The past and its difficulties fell away as the family became a unit and a new and especially happy era began. After the girls entered college, Sylvia continued her studies at Delta and Sacramento. As Shellenberger puts it, "She could finally pursue her education—fiercely!" During the master's program, she became interested in community history. "I struck gold," she recalls.

The golden bits of information were at Stockton Rural Cemetery, four volumes containing 1,296 names of Chinese, originally buried in the cemetery's northwest corner. It was a document detailing the Chinese community from 1863 to 1936. She couldn't stop researching. She also buried herself at the county historical museum storage department, "way down there with the ostriches, at the zoo," says Shellenberger. The result was

what he calls "a tremendous gift to San Joaquin County and a huge gift to members of the local Chinese-American community."

SAMFOW: The San Joaquin Chinese Legacy was published in 1988 and was indeed eagerly received in the county and also the San Francisco Bay Area. She appeared at conferences and symposiums and discussed Asian American studies and other topics at numerous universities, colleges and community colleges. She taught from 1990 to 1995 at California State University–Stanislaus in Asian American studies. Invitations to write for scholarly journals followed, and television documentaries were shown as well. She and the book traveled up and down California for speaking engagements.

She founded her own press, Heritage West Books, in 1989, with a focus on niche publishing, particularly local history; the effort ended in 2000. Fourteen years after *SAMFOW*, she took charge of a project for Arcadia Publishing's "Images of America" series, and *The Chinese of Stockton* had its debut in 2002; it is in its third reprint. She and Shellenberger and four others produced *Stockton Crown Jewel: The Bob Hope/Fox California* in 2005, about the Stockton landmark theater.

And then, in the late 1980s, suddenly Sylvia realized she had been in Stockton for nearly thirty years. Stockton's Chinatown had been decimated, downtown was dying and the city council seemed to only feign concern. She was soon taking out candidate papers for a District 5 seat. "The Asian community was enthusiastic to get the first Asian onto the city council," she recalls. The district was what Sylvia called the very core of downtown—and was shaped like an AK-47. Landmark buildings, hospitals, banks and businesses rubbed shoulders with moldering Victorians and devastated public parks, everything divided by the Crosstown Freeway (so called because it connects Highway 5 to Highway 99).

Sylvia Minnick received 59.4 percent of the vote and joined a council that desired to transcend its image as a "Monday night circus." Sylvia's desire was to do her best for her district, but in the process, she discovered she was out of step with her new colleagues—among them Mayor Joan Darrah and Beverly McCarthy, both profiled in this book. First of all, she felt her fiscal conservatism made her a "square peg in a round hole." Additionally, her work to clean up the neighborhoods in the district created tension with a council that had not been consulted on such a process. "I got hammered down," she told the historical group. "I used to be 5-foot-7!" She was denied important committee appointments and at last reencountered those feelings of shame, low self-esteem and hurt dating from her early years. "But then I had an epiphany...Being

ostracized by my peers could turn into something positive...I emerged with a sense of freedom."

She spoke out against issues she disagreed with and jokingly referred to herself as "Her Majesty's Loyal Opposition," referring to the mayor. She continued to serve through two terms, until 1995. In 1992, she was appointed deputy assistant director–community liaison for California State Parks by Governor Pete Wilson. She was the highest-ranking Asian in the department and took on as her favorite project Pio Pico State Historic Park in Southern California. She revitalized the neglected patch of historic land named for Alta California's first governor.

She was asked by the governor to run against popular incumbent Mike Machado for state assembly in 1996. "I knew I was a sacrificial lamb," she recounts. "To say 'no' would be going against my boss, the governor." She did lose, but Wilson appointed her to the Department of Aging as assistant director for external affairs. She had also helped plan the state's sesquicentennial celebration.

Back in Stockton, she involved herself in the Chinese Benevolent Association, becoming its first female president in 1999. Through her efforts, the group opened a twenty-unit, low-income senior apartment complex, Quan Ying, at 301 South San Joaquin Street. The early part of the twenty-first century however, looked bleak to the activist. Her older daughter died in a climbing accident in Hawaii, and her beloved Richard passed away.

It was a time of looking back, taking stock. She had, before their deaths, established contact with her parents and was with them often at the end, bearing no grudge for the earlier trauma. "My choices in life made me the person I am," she writes. "I have no regret."

In fact, Minnick is now married to an old acquaintance, Wellman Chin. They reconnected at the fiftieth reunion of their junior high school. He accompanies her on her various speaking engagements throughout the area for her new book.

And so, for this survivor, a new chapter begins. She is wealthy in her wide circle of family and friends and has a splendid legacy of community and state service. "We have shared laughter, we've shared tears," she says. "We've connected, we've stayed in touch and all the while I believed in the philosophy of never burning bridges."

Maxine Hong Kingston

Behind the Black Curtains

Maxine Hong Kingston's life of storytelling began in Stockton's old Chinatown, in the laundry her family operated and in which she spent long hours. She learned the value of money—twenty-five cents equaled a white starched shirt—and through the hard work she made up games and listened in, when she could, to "laundry talk."

Often the tales were of a China they had all left behind. And some of the "village ditties" her parents sang on the farm a world away from Stockton turned out to be poetry, she discovered in her Asian literature class at the University of California–Berkeley. When Maxine graduated from Edison High School, she was awarded eleven scholarships.

She was fascinated by her mother's stories of China, listening to "talk-stories" about her ancestors. Mystical folk tales also proved intriguing. She explains the talk-story as a tradition that precedes writing in China: "People verbally pass on history and mythology and genealogy and how-to stories and bedtime stories and legends…It keeps the community together." Everyone who came into her parents' laundry spoke talk-story, and the young Maxine was steeped in a conglomeration of culture, history and poetry, including mythology.

Today, the author and scholar is an award-winning writer who in 2008 received a Medal for Distinguished Contribution to American Letters from the National Book Awards. President Bill Clinton commented on presenting her a National Humanities Medal in 1997 that she "brought the Asian-American experience to life for millions of readers and inspired a new

Famed author Maxine Hong Kingston shares the stories she learned in her parents' Stockton laundry. *Courtesy of the Bank of Stockton Archives.*

generation of writers to make their own unique voices and experiences heard…a world we've never seen but instantly recognize as authentic."

People throughout California are still listening closely to Hong Kingston's statements on her work and life. She read from her many collections of poetry, fiction and nonfiction, including the newest epic poem, *I Love a Broad Margin to My Life*, when she visited Oxnard College in 2013. The poem is a 229-page free-verse memoir. In it, she travels to China and back, with

various experiences and excursions included. "Kingston often wanders from strict chronology and allows the fictional and fabulist to bleed into the real part," noted a *New York Times* book review. Scenes from other books are revisited, and the reviewer calls the work "rich material."

The Oxnard talk of course included a reading from her very popular first book, *The Woman Warrior: Memoirs of a Girlhood Among Ghosts*. She was teaching creative writing at the Mid-Pacific Institute, a private school in Hawaii, in 1978 when she published the memoir. Reviewers and readers were impressed, calling it original and fierce, fresh and stylish. The book explores the power of tradition and the difficulties faced by second-generation Chinese in America.

Maxine Hong Kingston was called "Ting Ting" by her parents, Chinese immigrants from the village of Sun Woi, near Canton. Her father, Tom Hong, gave himself Thomas Edison's name after he came to New York in 1914 and worked in a laundry. He and his wife, Yin Lan, had two children in China who died. Yin Lan, or Brave Orchid, arrived in 1939. She studied and practiced medicine, like one of the figures in *The Woman Warrior*. Hong had been a scholar and teacher in China. They joined the large Chinese community in Stockton soon before Maxine and later five other children were born.

The historical Chinatown was first settled during the gold rush by Chinese from the Kwangtung Province. Many went on to find work with railroads and built the levees, and by 1880, the community was the third-largest Chinese enclave in the state. It was first located on Channel Street between Hunter and El Dorado Streets. After a devastating fire, residents moved to the south bank of Mormon Slough. The heart of the settlement when the Hongs arrived was East Washington Street between Center and Hunter Streets and was known for its bustling activity and gambling houses, of which Hong managed one before opening the New Port Laundry on North El Dorado Street. He often said he named his daughter after a frequent winner in the gambling house, a blonde. Kingston found her parents to be a "strong life force, passionate, dramatic, drama before your eyes."

She learned also to be unsure of her status as a female in this traditional community. "Feeding girls is like feeding cowbirds," she heard. Another common phrase used to underscore girls' inferiority was, "Better to raise geese than girls." She later commented, "I felt there was no room for me in my house...I had to make a big invisible world and that was the writing."

One interesting aspect of this feeling, scholar Diane Simmons points out, was her involvement with black curtains, which could trace back to

Stockton's blackouts during World War II. "I want to part them, and to see what is on the other side," Kingston notes. She began covering her school paintings with black ink. As a first grader, she scored a zero on intelligence tests after she covered the pages black.

Maxine found it difficult to grow up on the south side of Stockton, a tough neighborhood of racial discrimination and fighting. She confessed in 2006, at the dedication of the Maxine Hong Kingston Elementary School in Stockton, that she herself became a bully. "When you look at me and you see how small I am and you see how nice I am, you would think that it was someone else picking on me," she told the school's children. Instead, she donned her heaviest boots to run down boys at recess and kick them in the shins. In sixth grade, a shy girl got her hair pulled until she cried. "I was just going to bully her into talking." Disparaging her actions, she reminded students to resist hurting others. "I would like to think that maybe together we can build a school that doesn't have bullying. This has to come from you, from the kids."

As she moved into the higher grades, she found *Fifth Chinese Daughter* by Jade Snow Wong particularly inspiring. She won a five-dollar prize from *Girl Scout Magazine* at fifteen for the essay "I Am an American." An Edison High teacher, Marjorie Larsen, confesses she had little influence on the author but remembers other teachers speaking of her talent.

She was sent to the Berkeley campus to study engineering, her parents' wish. Miserable, she switched to English even though she felt guilty. "English was easy for me, so I shouldn't do anything that was easy," she writes. It was the time of the Free Speech Movement at Berkeley, which she still sees as a positive era, with student sit-ins and demonstrations promoting free speech and questioning governmental choices, such as the war in Vietnam. She married an actor, Earll Kingston, in 1962; they met during a production of Bertolt Brecht's *Galileo*. Their son, Joseph, was born the following year, and both parents taught in Hayward.

Committed antiwar activists by this time, the couple decided to move to Hawaii and "drop out." This meant bypassing supermarkets (which supported the "war economy") and foraging through garbage cans instead. They became involved in an AWOL (absent without leave) sanctuary for soldiers, and eventually Maxine returned to teaching. Later, she sent *The Woman Warrior* off to various publishing houses. Knopf picked it up, but its fame was secured when John Leonard, a *New York Times* critic, needed something short to review and chose it out of a pile. "This week a remarkable book has been quietly published," he wrote. "It is one of the best I've read for years."

The question then became, Who is Maxine Hong Kingston? She had become an "overnight sensation" at age thirty-six. She was positively reviewed, and the book won the 1976 National Book Critics Circle Award for Nonfiction. Academics loved the work. The Stockton native is now one of the most universally taught living American authors in colleges and universities.

Kingston had hopes of expanding the book into a larger work. *China Men* was published in 1980 and won the American Book Award for Nonfiction and was a runner-up for the Pulitzer Prize. It was based on her father's and other relatives' experiences as immigrants. The author soon became a Guggenheim fellow. Her third book, earning the PEN West Award in fiction in 1989, was *Tripmaster Monkey: His Fake Book*. In it, a fifth-generation Chinese American struggles against racism in 1960s San Francisco. Twelve prose selections are collected in *Hawaii One Summer*. The story of her experiences in the 1990s is told in *The Fifth Book of Peace*, released in 2003. Her home was destroyed in the Oakland Hills fire, and her father had recently died. The manuscript of *The Fourth Book of Peace* was lost in the flames, and for a time, she was unable to write. But she rewrote the 156 burned pages, and they eventually became part of the *Fifth Book*.

The author taught at the University of Hawaii and Eastern Michigan University, joining the University of California–Berkeley faculty in 1990. Now a professor emeritus, she lives in Berkeley and once commented to an interviewer, "I think I teach people how to find meaning" by examining the past and finding new meaning in, and connecting to, past occurrences.

Kingston has received many honors, including the 2008 Medal for Distinguished Contribution to American Letters at the National Book Awards ceremony. She also received the National Humanities Medal in 1997 and the John Dos Passos Prize for Literature in 1998.

She continues to write. "My writing is an ongoing function," she explains, "like breathing or eating."

Dr. Dawn Mabalon

Little Manila's Champion

D r. Dawn Mabalon had to go away to come home again.

She was studying at the University of California–Los Angeles and was reading author Carlos Bulosan's *America Is in the Heart* as part of her Filipino American history class. The 1946 novel included scenes from Stockton. Curious, she asked her father about the connection. Her father explained that the author used to eat at her grandfather's business, the Lafayette Lunch Counter, at 50 East Lafayette Street, in the heart of Little Manila, as the Filipino section of Stockton was called. He used it as his permanent address, part of the "community mailbox" Pablo "Ambo" Mabalon kept. He also ate free, as Mabalon couldn't bear to see a hungry man. Dawn was doubtful. She checked it out. Indeed, the author had been to the lunch counter and frequented the area known as Little Manila, archives at the University of Washington proved.

"Suddenly, my father's memories became history," she recalls. "The discovery was a life-altering one." Dawn set out to eradicate the "terrible silence" regarding the history of the once vibrant neighborhood.

Dr. Mabalon has set the history straight in her latest book, *Little Manila Is in the Heart*, with the title a tribute to Bulosan. The subtitle, *The Making of the Filipina/o American Community in Stockton, California*, recounts the Filipino experience here that dates from 1898. Thousands of immigrants arriving in the 1920s and 1930s were put to work harvesting the San Joaquin Delta and San Joaquin County fields. Dr. Mabalon indicates that the city "was at the center of a West Coast migratory labor circuit" from Alaskan canneries to

Her Filipino roots are now a mission for Dr. Dawn Mabalon, author and professor. *Courtesy of Dr. Dawn Mabalon.*

Southern California vineyards. Stockton was popular as year-round work was more readily available. The Filipinos were needed as cheap and transient farm laborers.

The Little Manila area was in four to six square blocks near Chinatown and Japan Town. It was a working-class section with its own businesses. Around fifteen thousand people lived there before World War II. Even today, Filipinos are the largest Asian American group in the county.

Old neighborhoods and the downtown were facing decimation after the war. For the Filipino Americans, the change would be dramatic. The

neighborhood would vanish, save for three buildings, in an urban renewal attempt. "City power elites lavished investment and attention on the north side and ignored development and social problems…in the city's south and east sides," she charges in "Losing Little Manila: Race and Redevelopment in Filipina/o Stockton, California," part of the book *Positively No Filipinos Allowed.*

Much of the very area that had been targeted by the U.S. Army as off-limits to armed forces personnel during the war was now part of twelve blocks west of the central business district called "Skid Row" by city planners and business leaders. Filipino, Japanese and Chinese residents called the area the West End and celebrated its ethnic neighborhoods and working-class businesses. "Downtown redevelopment" was the phrase used across the country as the Housing Act of 1949 gave cities millions to revamp what they saw as "blighted" areas. Stockton was joined by more than seven hundred other cities from 1949 to 1967 for slum clearance and housing for citizens who were moved into other neighborhoods.

In 1952, the Stockton City Planning Commission called the city's West End and much of the central business district "infested" and proposed redevelopment. The Urban Blight Committee was in 1955 calling the West End an eyesore that needed to be cleaned up. The city council created the Redevelopment Agency the following year and earmarked nine blocks for demolition, and work started in early 1964.

The final decimation of the area—over 460 homes, 126 businesses, six churches, a park, a school and farmland—came with the construction of the Crosstown Freeway. The Washington-Lafayette "corridor" route was approved at the end of 1971, and according to Dr. Mabalon and other supporters of Little Manila, the decision was a disaster. "As former colonials accustomed to a long tradition of racial discrimination at the hands of Stockton officials, [Filipinas/os] probably felt powerless to stop the demolitions," she writes.

Besides Little Manila, Chinatown and Nihonmachi (Japan Town) were also uprooted. Still standing, and listed on the National Register of Historic Places, is the Nippon Hospital, established in 1919 to serve Stockton's Japanese population, one of the largest such communities in the nation. The poor care the Japanese received during the 1918 influenza epidemic galvanized the residents into founding the hospital.

Another survivor is the restaurant On Lock Sam, originally located at 125 East Washington Street between Hunter and El Dorado in 1898. Wong Sai Chun and two partners bought the eatery in 1920, possibly because Stockton's prosperous Chinese community promised rich profits.

With their old section of town destroyed, Filipinos moved throughout the city and were boosted with family reunification guaranteed under the 1965 Immigration Act. In 1992, Filipino Americans founded the Stockton Chapter, Filipino American National Historical Society (FANHS), which in turn fought to designate the Little Manila Historic Site in 2000, encompassing the blocks surrounding El Dorado and Lafayette Streets.

Dr. Dawn Bohulano Mabalon is a tenured associate professor in the history department at San Francisco State University. She has, for years, been engaged with the Filipino community, focusing on preserving and sharing the history. The research that began in a Washington State archive blossomed into advocacy for her old neighborhood. She is both a co-founder and board member of the Little Manila Foundation, which works for the preservation and revitalization of the Little Manila Historic Site in Stockton. She is a member of the local FANHS chapter.

An activist and scholar, Dr. Mabalon always wanted to be a writer. A third-generation Pinay, she was born in the city in 1972 to Christine Bohulano Block, who taught at Manteca and Stockton elementary schools, and the late Dr. Ernesto Tirona Mabalon. He was a farm laborer and contractor in the Delta. Her grandfathers arrived on the West Coast from Numancia, Aklan province, on the island of Panay, and settled in Stockton in 1929.

She was raised in a close-knit, large Filipino American family on the city's South Side, on Jefferson Street near Hazelton School. She attended Hazelton, was bused to Hoover, edited the student newspaper at Marshall Middle School and went on to Edison High, San Joaquin Delta College and UCLA. She has one sister, Darleen Mabalon, and now lives in San Francisco with her Filipino American musician husband, Jesus Perez Gonzales.

These significant accomplishments weren't the end of her education. After receiving her bachelor's degree in history with a specialization in Asian American studies (magna cum laude) in 1992, she earned her master's in Asian American studies from UCLA in 1997. Then it was on to Stanford University on a full fellowship to pursue her doctorate in American history.

Dawn Mabalon, who remembers as a five-year-old being served hotcakes at the Lafayette Lunch Counter by her beloved *lolo* (grandfather), became the first Filipina to complete a PhD in history at Stanford in 2004. Her mind often returns to such homely scenes as the lunch counter. "This was not history to me, at least not then. This was just another morning, my father's day off from work in the fields, with my favorite breakfast."

In addition to her interests in Philippine and Filipina/o history, Dawn anticipates writing a book examining Filipino American food and culture.

She has an essay in the new anthology *Eating Asian American.* She often returns to Stockton for personal and even professional reasons; she was part of the author contingent at the massive Stockton love-in called "Stockton Is Magnificent" on the city's Miracle Mile in the fall of 2013.

She was selling her Little Manila book but also has a number of titles to her credit: *Tomorrow's Memories: The Diary of Angeles Monrayo* (2003); *Coming Home to a Landscape: Writings by Filipinas* (2003); *Pinay Power: Pilipina Feminist Theory* (2006); *Positively No Filipinos Allowed* (2006); and in both volumes of the *Pinay Educational Partnerships: A Filipina/o American Sourcebook* (2007). She is a co-author of *Filipinos in Stockton* and co-edited *Filipinos in San Francisco*, both Arcadia Press offerings from 2008 and 2011, respectively. She and two of her books were the subjects of a PBS documentary.

She also returned to her hometown for the official launch of *Little Manila*, choosing as the venue the historic Hotel Stockton. During her father's time, no Filipino could enter those doors as a guest. When her grandfather sent for his son, Ernesto Mabalon found that his medical degree from the University of Santo Tomas in Manila meant nothing in 1963 Stockton. The signs "No Filipinos Allowed" may have been taken down by then, but the prejudice continued. He had been put through college by his father's work at the lunchroom. But he was unable to get his license here "because of discriminatory laws," his daughter says. Considering all work honorable and dignified, he settled for a job in the fields and became a labor contractor. Off duty, he served as president of the Filipino Community of Stockton. A fraternal order, Legionarios del Trabajo, was also a pastime.

And like many of the community elders, the community and its destruction were not topics for discussion. The Lafayette Lunch Counter was bulldozed with the rest for the Gateway Project, part of urban development. The intention was to make the corner work as an attraction to those entering Stockton from the freeway. It got a gas station and a McDonald's, where, ironically, dozens of Mexican Americans daily wait to be picked up for day jobs.

Dawn knows she cannot re-create the wonderful, cohesive atmosphere of Little Manila, which she calls the heart of Filipino history in America. What she doesn't want is for this history, and the memories, of this place to be destroyed or forgotten. She will continue to write and teach this important subject that is in the core of her own heart. And just to make sure that history can come alive, she has taken a page from her *lolo* and picked up her wooden spoon. In her spare time, she is a caterer—Dr. Dawn's Baking Company in San Francisco offers Philippine and Filipino baked goods.

Beverly Fitch McCarthy

Frankly Feminist

To say that Beverly Fitch McCarthy is active in Stockton political, feminist, societal and organizational circles is akin to announcing that F. Scott Fitzgerald was a popular writer. It's a given. Her resume is unending. Her optimism is boundless. And her service to the community is truly remarkable. How *did* she find the time?

"I have been this way from childhood," she explains over lunch at the Stockton Golf and Country Club. Of course, she's a member. Early on, she was aware of racial inequities and says she was probably a feminist from the cradle. She is undoubtedly Stockton's pioneer feminist figure, having sent a cactus to the all-male Yosemite Club (now defunct) and chaired the San Joaquin County Commission on the Status of Women for twenty of her thirty years of membership. Helping the impression of her as a woman "on the go" is that she always seems on the move, in a rush, with an ebullience she can't hide under one of her trademark picture hats.

An entry into politics—the city council and the school board—earned her a "thick hide." She's been called a "femiNazi," derided for her liberal politics and was even sniped at in the local press for advocating the singing of patriotic tunes in the classroom. As a teacher for twenty-five years, Beverly advocates teaching the historical message behind many old favorites now out of fashion.

Beverly was an overachiever at home in St. Louis, Missouri, before the family moved to California in 1948, where she entered her first integrated school, Venice High. In St. Louis, "everything" was segregated, and the only

Whirlwind Beverly Fitch McCarthy says she was born a feminist. *Courtesy of Beverly Fitch McCarthy.*

African American she knew was the family's maid, Sophie. For college, she chose the University of California–Berkeley and received a bachelor of arts degree in (naturally) two subjects, social science and physical education, in 1956. She won the California Alumni Scholarship in 1953 and the Caswell Scholarship for Leadership the next year.

Unusual for a woman at the time, Beverly went on to receive a master's degree from Stanford University with a major in education/student personnel and guidance. She attended the prestigious university on a fellowship and was an intern on the dean of women's staff. Beverly also headed her first post–high school group, the Cal Women Students, becoming president and serving on the student council. She made the front page of the *Daily Cal* for her work integrating the previously all-male rooting section. She went on to teach full time at Monterey Peninsula College, Santa Barbara City College and San Jose City College.

She came to Stockton in 1962, serving until 1985 as a counselor/instructor in psychology, marriage and the family; dance and individual conditioning; and educational planning at San Joaquin Delta College. She directed the Re-Entry Program for women and men from 1974 to 1985 and received yet another credential: the 1980 Education Administrative Credential from the University of the Pacific. In 1977–79, she acted as state president of California Women in Higher Education.

Beverly says she retired in 1985—one doesn't believe her. The workplace may have been exited, but at fifty-two, she had no intention of slowing down. She and her husband, John, a local noted church organist, were just warming up. John taught for over forty years. Before joining the San Joaquin Delta College faculty, he taught at the old Stockton High School, Stagg High (where he wrote the Stagg Alma Mater) and Franklin. He earned his master's degree from UOP. At Cal, he was a music major and math minor.

Beverly had already marched for the United Farm Workers and continues personal boycotts of businesses she believes aren't treating their employees correctly. In her main activist period, in the 1960s and 1970s, she also marched for Planned Parenthood in Stockton—she was informed by counter-protestors that she would burn in hell—and objected to National Secretary's Day, as she believed secretaries were underpaid. She wrote a letter to the editor of the *Stockton Record* about sexual harassment and ended up invited to deliver a standing room–only talk to Stockton Unified School District administrators. "I just let them have it," she says. "But I never got a thank-you note or card."

Of her protests, she remarks, "By the way, there was never a bra burned." She pauses. "Maybe a girdle."

Many a club and organization have benefited from her presidency and involvement. Four times she has headed the Stockton Opera Guild. Other arts groups she has chaired include the Stockton Opera Association; the Stockton Civic Theatre League; the Stockton Symphony Association and

the Alliance; and the Haggin Museum Department of Museum Travel Auxiliary. Such involvements led to her and John being chosen in 2010 for the Stockton Arts Commission's highest accolade, the STAR Award (Stockton Top Arts Recognition), for participation, support and contributions to the arts. She had been an arts recognition recipient in 1978.

Additional presidencies include the historic Philomathean Club; Stockton Chapter, American Association of University Women; Sunflower Presents, Inc. (performers who entertain convalescent home residents); Auxiliary to the county Child Abuse Prevention Council; the county Family Resource and Referral Employer-Supported Child Care Coalition; the Stockton Redevelopment Commission; and the county National Women's Political Caucus.

For many years, she chaired the Commission on the Status of Women. "We have put on twenty-two major conferences using the facilities of Delta College and UOP," she says. "One year, we wanted a woman lawyer to speak on wills and trusts. So I called the County Bar Association and learned that there were exactly twelve women practicing law in the entire county. We have certainly come a long way in that career choice," she jokes. "We have sponsored thirty-four Susan B. Anthony Banquets honoring these women of achievement, supported Affirmative Action when it was the law in California, worked diligently on pay equity and comparable worth issues, worked with Lincoln and Stockton Unified School Districts to ensure compliance with the new Title IX legislation and through our Talent Bank encouraged women to apply for boards and commissions and, yes, even run for office...I never thought I would see the day that the Stockton City Council would have five women serving."

Beverly received the Anthony honor herself in 1983. (The San Joaquin County Commission on the Status of Women was founded in November 1974 and was first called the SJC Women's Council. "We changed the name when we became aware of other commissions in the state of California. And we wanted to be a part of them. Collectively, they are referred to as the California Commission on the Status of Women," she clarifies.)

Beverly has been especially noted for her feminist work throughout the city and county. She received Resolution 265 from State Senator Patrick Johnston and Assembly Member Michael Machado in 1999 for founding the San Joaquin Board of Directors for the National Association of Commissions for Women in 1977.

If it all sounds like rather a slog, it wasn't, Beverly says, insisting, "It was fun every inch of the way." She relished being the event coordinator in 1998 for the 150th Anniversary Celebration of Women in America, 1848–1998,

with Jackie Speier as keynote speaker. Speier is now the United States representative for California's Fourteenth Congressional District. Speier had just lost her husband and had her new baby with her. "We were thrilled to have her," Beve says. "Some of us came to the luncheon, at Elkhorn Golf and Country Club, dressed in 'suffrage' clothes and carrying placards." In 1995, she co-chaired the Women's Suffrage 75th Anniversary Celebration at Stockton Golf and Country Club (SGCC).

Yet another event at SGCC, a 2007 Veteran Feminists of America (VFA) awards luncheon honoring county women, included the national president, Jacqui Ceballos, who gave opening remarks and bestowed several dozen medals. This event was sponsored by the Commission on the Status of Women.

In between all this in her resume are the facts that, yes, she was elected to two high-ranking local posts, the Stockton City Council, representing District 4, in 1990, and the Stockton School Board, from which she just retired. She strategized with Mayor Joan Darrah, whom she knew from Berkeley, and lived a block apart from her on Monterey Street in Stockton. They started a "war chest" to help favored candidates get elected to the council. "I had the support of the [Stockton] Port officers, and I always say that's why I got elected," she notes. She took on the school board post in 2006, beginning "the four hardest years of my life." But she is philosophical. "When you're in politics, there will always be people who don't like you." She kept her husband as her sounding board and went to bed each night thinking, "I did the best I could."

Her other reflection on politics: "Get the lawn signs out before they send the absentee ballots."

Right now, much of Beverly McCarthy's enthusiasm is directed at the National Board of Veteran Feminists of America. She was elected to the board in 2010 and serves through this year.

"We still have a long way to go," she says, referring to feminism. She is pleased to have met both feminist icons Betty Friedan and Gloria Steinem; the former attended a women's commission dinner after giving a talk at University of the Pacific.

The Veteran Feminist organization calls itself the "Second Wave women's movement for journalists, historians, and other writers." Beverly is fresh from the latest conference, held in September 2013 in Los Angeles. Singer Helen Reddy appeared. Dr. Paula Caplan, writing in a blog for *Psychology Today*, found the event energizing: "When the Second Wave began in the late 1960s, who would have thought that in 2013, so much would have been achieved but so much would remain to be done?"

It was quintessential Beverly McCarthy when she celebrated her eightieth birthday. Several hundred guests were welcomed to dinner in an art-bedecked room at the Haggin Museum, and all unfailingly dressed for a "Meet Me in St. Louis" theme. It was just what she hoped for. She also got things done the McCarthy way for the event she chaired, the fall Opening Luncheon of the Philomathean Club's 120th year. At the end of the entertainment—a vocalist and pianist—she beamed at the two young performers. "Show tunes!" she exulted. "Just what I wanted!"

Bibliography

Chapter 1: The Sperry Sisters

Birmingham, Stephen. *California Rich.* New York: Simon and Schuster, 1980, 71, 137–38, 140.

Brush and Pencil 18, no. 2. "Details of Art Loss in San Francisco." (August 2, 1906). www.jstor.org/stable/25504031.

Burgett, Shirley, and Michael Svanevik. "Portraits of Dedication." San Mateo County Women's Hall of Fame, 1984–1994. traubman.igc.org/pod.pdf.

MacColl, Gail, and Carol McD. Wallace. *To Marry an English Lord.* New York: Workman Publishing, 1989, 137.

Martin, V. Covert. *Stockton Album Through the Years.* Stockton, CA: Simard Printing Co., 1959, 113.

Montecito Journal. "Landmark: Birnam Wood Before the Golf Course." (Winter/Spring 2010–11). themjmag.com/5/index.html#41.

Pittsburgh Press. "Elizabeth Sperry Becomes Princess Poniatowski." July 11, 1915. news.google.com/newspapers?nid=1144&dat=19150711&id=chk hAAAAIBAJ&sjid=PEkEAAAAIBAJ&pg=1315,2716035.

Ryder, David Warren. *Great Citizen: A Biography of William H. Crocker.* San Francisco: Historical Publications, 1962, 60, 66, 80, 85, 95, 135–37.

Chapter 2: Julia Weber

Engh, Peggy Ward. "On the Road Again: The Final Journey of the Julia Weber Home." Lodi, CA: San Joaquin County Historical Society & Museum, 2001.

An Illustrated History of San Joaquin County, California: Containing a History of... Chicago: Lewis Publishing Co., 1890, 289–90.

Jacobs, Marian. *Lady Constance: The Collected Letters of Constance Miller.* Stockton, CA: Stockton Record & Stockton Savings Bank, 1991, 124–25.

Lewiston Evening Journal. "She Returned Property Worth $1 Million." January 26, 1897.

MacColl, Gail, and Carol McD. Wallace. *To Marry an English Lord.* New York: Workman Publishing, 1989, 137.

San Francisco Call. "Mrs. Watson Becomes Wife of Mr. Ferris in New York." June 4, 1906.

———. "Will Contest Dismissed." December 4, 1898.

St. Joseph's Medical Center. www.stjosephscare.org/Who_We_Are/History/index.htm.

Stockton Record. "Laogier Home, Later Known as Wheeler Home; Historic Landmark Is Razed for Oil Station." February 21, 1950.

Walker, Don. "Julia's House." *San Joaquin Historian.* A Publication of the San Joaquin County Historical Society & Museum 14 (Winter 2000).

Wik, Reynold M. *Benjamin Holt & Caterpillar: Tracks & Combines.* St. Joseph, MI: American Society of Agricultural Engineers, 1984, 31.

Chapter 3: Inez Budd

"California's Capitol." www.californiascapitol.com/calcap/2012/05/happy-birthday-governor-budd.

California State Parks Office of Historic Preservation. ohp.parks.ca.gov/?page_id=21388.

First Ladies of California. firstladies.library.ca.gov/17-Budd.html.

Guinn, J.M. *History of the State of California and Biographical Record of San Joaquin County.* Vol. 2. Los Angeles: Historical Record Co., 1909, 42.

Los Angeles Herald. "Charges Against Mr. Budd—The Records of Three Courts Declare Them Untrue." October 24, 1894.

National Governors Association. "California Governor James Herbert Budd." www.nga.org/cms/home/governors/past-governors-bios/page_california/col2-content/main-content-list/title_budd_james.html.

Sacramento Daily Union. "The Brilliant Social Event of Last Night." January 29, 1895.

San Francisco Call. "Bequests of Mrs. Budd Are Invalid." June 6, 1912.

———. "Budd Family Divided over Mrs. Dumouriez." August 2, 1909.

———. "Budd's Secret Is at Last Revealed." August 18, 1908.

———. "Clear at Stockton: Throngs See Comet." May 25, 1910.

———. "Governor's Widow Expires Suddenly." May 16, 1911.

————. "Legal Battle May Bare Budd-Dumouriez Mystery." September 21, 1908.

————. "Relinquishes Claim to Budd's Estate." January 15, 1909.

————. "Suit May Bare Mystery in Life of Late Gov. Budd." September 21, 1908.

San Francisco Evening Post. "Extra! James H. Budd. Startling Chapter in His History." October 20, 1894.

Stockton Daily Independent. "Estee's Meeting." October 24, 1894.

————. "Inaugural Ball; California's Capitol Ablaze with Light." January 29, 1895.

Stockton Evening Mail. "Stockton's Lady Astronomer." September 30, 1901.

CHAPTER 4: L. CLARE DAVIS

Harris, Gloria G., and Hannah S. Cohen. *Women Trailblazers of California: Pioneers to the Present.* Charleston, SC: The History Press, 2012, 47.

Husse, Fredrick, in conversation with the author, January 7, 2013.

Kingsbury's Directory of Stockton City and San Joaquin County, 1891–94.

Los Angeles Herald. "A Woman's Honest Confession." September 11, 1897.

McNair, Cathy. *One Hundred Years of Learning the Philomathean Way—In the Beginning, 1893–1993.* Stockton, CA: privately printed, May 1993.

1900 Federal Census. www.ancestry.com.

Reno Evening Gazette. "The Path to Success." September 10, 1904.

San Francisco Call. "Stockton Trustee Resents a Slight." February 3, 1911.

Stockton Daily Evening Mail. "It Blew Great Guns." November 17, 1893.

Stockton Evening Record. "End of a Life 'Along Highways and Byways.'" August 22, 1947.

————. "Last Tribute Paid L. Clare Davis at Simple Rites." August 25, 1947.

————. "L. Clare Davis Rites Are Set." August 22, 1947.

————. "Pete and His Pipe." September 20, 1947.

CHAPTER 5: SARAH GILLIS

Colberg, Wilton. "Early Days on the San Joaquin River." *Far Westerner* 5, no. 4 (October 1964).

Martin, V. Covert. "River Steamboats of Stockton." *Far Westerner* 1, no. 1 (January 1960).

————. *Stockton Album Through the Years.* Stockton, CA: Simard Printing Company, 1959, 75–82.

McCullough, David. *Path Between the Seas: The Creation of the Panama Canal.* New York: Simon & Schuster, 1977, 23.

Morton, C. Tracy, collector. *Rob and Merren Reminisce.* Gillis family publication, December 1971, 24–27.

Oakland Tribune. "The Knave." January 24, 1932.

Philomathean Club Records, MS 295. Holt-Atherton Department of Special Collections, University of the Pacific Library.

Smith, Alan "Sandy" (retired attorney, Stockton property owner), in conversation with the author, April 2011.

Stockton Evening Record. "James Gillis Is Kicked to Death; Murderous Work of His Own Horse." July 2, 1904.

Stockton Record. "Rites Held for Robert M. Morton, Engineer of First Paving in S.J." July 3, 1969.

———. "Sarah Hayes Gillis." January 12, 1932.

———. "Society Items." June 24, 1911.

Tayor, Clotilde Grunsky, ed. "Dear Family: The Story of the Lives of Charles and Clotilde Grunsky, 1823–1891." Manuscript of the estate of Alan "Sandy" Smith, Stockton, CA.

Chapter 6: Lottie Ruggles

Elrod, Amanda, coordinator, Donor Relations and Stewardship, University Development, University of the Pacific, in conversation with the author, January 16, 2013.

Gjenvick-Gjonvik Archives. www.gjenvick.com/HistoricalBrochures/Steamships-OceanLiners/1910-TravelGuide/LowestTransatlanticOceanRates.html.

A "Grand Tour." 1910 Travel Guide. www.gjenvick.com/HistoricalBrochures/Steamships-OceanLiners/1910-TravelGuide/AGrandTour.html#ixzz2E2OzXjA9.

The Inflation Calculator. www.westegg.com/inflation/infli.cgi.

Kurey, Gertrude, in conversation with the author, June 15, 2010.

Lottie Ruggles Letters. Box 25, Folder 1. California State Library, Sacramento.

Martin, V. Covert. *Stockton Album Through the Years.* Stockton, CA: Simard Printing Co., 1959, 158.

"The 1900s: Education: Overview." encyclopedia.com. www.encyclopedia.com/doc/1G2-3468300064.html.

Sacramento Bee. "Dr. C.A. Ruggles Called by Death." September 12, 1906. genealogytrails.com/cal/sjoaquin/transobitindex.html.

San Francisco Call. "Attractive Features for Stockton Street Fair." May 28, 1900.

———. "Bride Is Guest of Honor at Tea." March 6, 1911.

———. "Clubwomen Read Products of Pens." May 23, 1910.

————. "Clubwomen Speak on Writers' Lives." January 31, 1910.

————. "Clubwomen Study Sculptors' Lives." April 25, 1910.

————. "History Discussed by Philomatheans." March 7, 1910.

————. "Officers Elected by Schoolwoman's Club." May 12, 1912.

————. "Women Interested in Chamber of Commerce." March 22, 1912.

————. "Women to Talk at Clean-Up Day Luncheon." April 17, 1912.

Stockton Record. "C.O.P. Benefits by Generosity." August 30, 1960.

Tinkham, George H. *History of San Joaquin County, California: With Biographical Sketches of Leading Men and Women of the County Who Have Been Identified with Its Growth and Development from the Early Days to the Present.* Los Angeles: Historic Record Co., 1923, 200, 202.

CHAPTER 7: ANNA BROWN HOLT

"Benjamin Holt and the Holt Family." *Americana Illustrated.* Vol. 30, no. 3. New York: American Historical Society Inc., 1936, 560.

Holt, B.D., in conversation with the author, January 12, 2012.

HOLT CAT Company information received July 13, 2012; sourced from *The End of the Line* and Holt Family Chronology.

Holt, Catherine, in conversation with the author, March 10, 2012.

Holt, Harry D. *The End of the Line.* N.p.: self-published, 1991, 11, 17.

Holt, Nick, in conversation with the author, March 10, 2012.

National Register of Historic Places. nrhp.focus.nps.gov/natregsearchresult. do?fullresult=true&recordid=0.

1900 Federal Census. www.ancestry.com.

Oakland Tribune. "Holt Bequeaths Huge Estate to Wife, Children." December 28, 1920.

————. "Mrs. Holt Fetes Stockton Club." June 12, 1937.

Peter M. Holt Family Chronology, November 1, 2011. Courtesy of the HOLT CAT Co., July 13, 2012.

RitchieWiki: Everything about Equipment. www.ritchiewiki.com/wiki/index.php/Benjamin_Holt#ixzz1pV5aaJf2.

Sicotte, Nancy Johnson. *The Life Story of Benjamin E. Brown and Lucy Dean Brown, Early California Pioneers.* Palo Alto, CA: self-published, 1992, 5.

Stuart, Reginald R., and Grace D. Stuart. *Tully Knoles of Pacific: Horseman, Teacher, Minister, College President, Traveler, and Public Speaker.* Stockton, CA: College of the Pacific, 1956, 23.

University of the Pacific. web.pacific.edu/x1526.xml?ss=print.

Wik, Reynold M. *Benjamin Holt & Caterpillar: Tracks & Combines.* St. Joseph, MI: American Society of Agricultural Engineers, 1985, 3.

CHAPTER 8: HARRIET CHALMERS ADAMS

Anema, Durlynn. *Harriet Chalmers Adams: Adventurer and Explorer.* Aurora, CO: National Writers Press, 2004, 7, 11–12, 19–20, 22–23, 33, 50, 62–64.

CBS News. "Columbus Remains Found in Spain." February 11, 2009. www.cbsnews.com/2100-202_162-1636214.html.

Davis, M. Kathryn. "The Forgotten Life of Harriet Chalmers Adams: Geographer, Explorer, Feminist." Dissertation for master of arts in history, San Francisco State University, 1995, 20–21, 26–29, 31, 51, 61, 110–11.

New York Times. "Harriet Chalmers Adams, Explorer, Is Dead." July 18, 1937.

CHAPTER 9: DR. MARGARET SMYTH

Carroll, Melanie. "Doctors Row Homes Under Renovation." *Stockton Record,* January 1, 2005.

Martin, V. Covert. *Stockton Album Through the Years.* Stockton, CA: Simard Printing Company, 1959, 136–37.

Rohrbacher, Richard W. "Margaret Hamilton Smyth, M.D.: A Capable and Qualified 19th Century Woman." *Dogtown Territorial Quarterly* 49 (Spring 2000).

Smith, Dave, and Justin Jones. "Ahead of Its Time: The Stockton State Mental Asylum from the 1890's to 1920's." University of the Pacific. www.pacific.edu/cop/jacobycenter/projects/Stockton%20History%20II/mental.htm.

Starr, Neal L. "Stockton State Hospital: A Century and a Quarter of Service." *San Joaquin Historian* 12, no. 4 (October–December 1976).

CHAPTER 10: TILLIE LEWIS

Albala, Ken. "Tomato Queen of San Joaquin." From files of Alice van Ommeren.

CA&ES Outlook. "Helping Grow the California Tomato." (Fall–Winter 2013).

Food Packaging. December 1975.

Letter from Alilea Hayward Martin to Gwen Thompson, Haggin Museum, 1983.

McCormack, William. "Tillie Lewis." Dissertation for bachelor of arts in history, California State College–Stanislaus, 1968.

PR Web. "U.S. Weight Loss Market Worth $60.9 Billion." www.prweb.com/releases/2011/5/prweb8393658.htm.

Schleier, Merrill. "Tillie the Toiler or Tillie the Tomato: The Production of Food and the Construction of Gender by Tillie Lewis of Flotill Foods." *Far Westerner* 38 (Spring–Summer 1997).

Chapter 11: Edna Gleason

Matuszak, Alice Jean, Penny A. Nichols-Melton and Alice Okamoto. "Edna Gleason: They Called Her 'Dynamite.'" *California Pharmacist* (September 1993): 26–28, 44.

Program, Gleason Park Dedication Ceremony, March 19, 1975.

Stockton Record. "Councilwoman Is Cut Rate Foe." October 23, 1951.

———. "Edna Gleason Seated by Council." October 23, 1951.

———. "Gleason Park Unveiled as Redevelopment Triumph." September 16, 2011.

———. "Hawkins' Challenge of Fair Trade Act Stirs Rumble from 'Mother' of Act." February 23, 1950.

———. "Mrs. Gleason Now a Licensed Pharmacist." February 17, 1922.

———. "Pharmacists Honor Mrs. Edna Gleason." June 15, 1954.

Chapter 12: Emily Knoles

"A Colorful History." www.deltacollege.edu/dept/ar/catalog/cat0304/aboutsjdc3.html.

Hayward Daily Review. "540 Honor COP President." January 7, 1956, 25.

Oakland Tribune. "Dr. Tully Knoles to Keynote Student Government Parley." November 19, 1959.

Pacific Review 12, no. 1. "Reflections of a Former UOP First Lady on Her 100th Birthday: Emily Knoles." (1977).

Sawyer, Eugene T. *History of Santa Clara, California.* Historic Record Co., 1922, 511, transcribed by Marie Clayton. www.mariposaresearch.net/santaclararesearch/SCBIOS/tcknoles.html.

Stockton Daily Independent. "Philomathean Club to Be Presented Literature of Optimism in Year's Program on 'New Renaissance.'" October 16, 1924.

Stuart, Reginald R., and Grace D. Stuart. *Tully Knoles of Pacific: Horseman, Teacher, Minister, College President, Traveler, and Public Speaker.* Stockton, CA: College of the Pacific, 1956, 23, 24, 46.

Tully C. Knoles PTSA/School Newsletter. "Just Who Was 'Tully C. Knoles'?" September 5, 2007.

Wurtz, Michael, librarian, University of the Pacific Library, Holt-Atherton Special Collections, in conversation with the author, March 15, 2013.

CHAPTER 13: ELIZABETH HUMBARGAR

The Encyclopedia of Arkansas History & Culture. "Rohwer Relocation Center." www.encyclopediaofarkansas.net/encyclopedia/entry-detail. aspx?entryID=369.

Flaherty, Marjorie, and David Johnson. *The Other Side of Infamy, a Joint Project between the Stockton Chapter, Japanese American Citizen's League, and the Association of Asian American Educators.* Contains the *Stockton Record*'s 1982 award-winning series of articles on the experiences of local Japanese-Americans interned during World War II. N.p., n.d.

Seigel, Shizue. *In Good Conscience: Supporting Japanese Americans During the Internment.* San Mateo, CA: AACP, Inc., 2006, 61–63, 66, 69, 70–71.

Stockton Record. "No Japanese Left in Stockton as Nearly 1000 More Moved." May 13, 1942.

U.S. History: Pre-Columbian to the New Millennium. "Japanese-American Internment." www.ushistory.org/us/51e.asp.

CHAPTER 14: WILHELMINA HENRY AND FLORA MATA

Henry, Wilhelmina, in conversation with the author, October 17, 2013.

KQED News. "Stockton's Little Manila: The Heart of Filipino California." September 2, 2013. blogs.kqed.org/newsfix/2013/08/29/little-manila-the-heart-of-filipino-california.

Leagle. *Hernandez v. Board of Educ. of Stockton.* www.leagle.com/decision/200 42625CalRptr3d1_126.

Little Manila, Stockton, CA. Remember and Reclaim. www.littlemanila.org.

Mata, Sheree, in conversation with the author, October 21, 2013.

National Council of Negro Women. www.ncnw.org.

Stockton Record. "City's First Black Teacher Honored for Life's Work." September 8, 2006.

———. "Local Chapter of Black Sorority Marks 35 Years." June 22, 2013.

———. "Pioneer Educator Devoted Lifetime to SUSD." September 17, 2013.

Stockton School District Board of Education, February 28, 2013. blogs. esanjoaquin.com/stockton-education/files/2013/02/2013-02-28-Special-Meeting-Agenda.pdf.

CHAPTER 15: JOAN DARRAH

Darrah, James, in conversation with the author, November 8, 2013.

Darrah, Joan, and Alice Crozier. *Getting Political: Stories of a Woman Mayor.* Sanger, CA: Quill Driver Books/Word Dancer Press, 2003.

Lodi News Sentinel. "Ronk Vows Battle to Retain Seat on Stockton Council." July 5, 1985.

Stockton Record. "Ex–Stockton Mayor off to State Prison." April 20, 1996.

———. "Former Mayor Joan Darrah Succumbs to Cancer." July 28, 2007.

Chapter 16: Dolores Huerta

American Postal Workers Union, AFL/CIO. www.apwu.org/laborhistory/03-2/doloreshuerta/03-2_DoloresHuerta.htm.

Campbell, Duane. "Dolores Huerta to Be Inducted into California Hall of Fame." California Progress Report. www.californiaprogressreport.com/site/dolores-huerta-be-inducted-california-hall-fame.

Doak, Robin S. *Dolores Huerta: Labor Leader and Civil Rights Activist.* Minneapolis, MN: Compass Point Books, 2008, 17, 22, 43, 60–63, 69–71, 83–84, 86–87.

Dolores Huerta Foundation. www.doloreshuerta.org.

Harris, Gloria G., and Hannah S. Cohen. *Women Trailblazers of California: Pioneers to the Present.* Charleston, SC: The History Press, 2012, 71–74.

Kallen, Stuart A. *We Are Not Beasts of Burden: Cesar Chavez and the Delano Grape Strike.* Minneapolis, MN: Twenty-first Century Books, 2010.

National Women's History Museum. "Dolores Clara Fernandez Huerta." nhwm.org.

Stockton Record. "Touching Tribute." April 11, 2003.

———. "2500 Gather to Encourage Farm Workers Pilgrimage." April 4, 1966.

Chapter 17: Sylvia Sun Minnick

Minnick, Sylvia Sun. *Never a Burnt Bridge.* Stockton, CA: SMC Press, 2013.

San Joaquin County Historical Society General Membership Dinner, October 28, 2013.

Stockton Record. "Minnick's a Memoir of Sorrow and Spirit." August 28, 2013.

Chapter 18: Maxine Hong Kingston

The Biography Channel. "Maxine Hong Kingston." www.biography.com/people/maxine-hong-kingston-37925.

Downtown Stockton Alliance. "Spirit of Stockton's Chinatown." downtownstockton.org/stockton_history.php.

Encyclopedia of World Biography, September 14, 1998. madrono.stockton.lib.ca.us:2101/ic/bic1/ReferenceDetailsWin.

New York Times. "Maxine Hong Kingston's Life in Verse." March 11, 2011. www.nytimes.com/2011/03/13/books/review/book-review-i-love-a-broad-margin-to-my-life-by-maxine-hong-kingston.html?pagewanted=all&_r=0.

Simmons, Diane. *Maxine Hong Kingston.* New York: Twayne Publishers, 1999, 5–10, 14–15.

Stockton Record. "Author Highlights Dedication of Namesake School." November 16, 2006.

University of Minnesota. "Maxine Hong Kingston." voices.cla.umn.edu/artistpages/kingstonMaxine.php.

Chapter 19: Dr. Dawn Mabalon

Bennett, Michael. "On Lock Sam—In the Heart of the Third City." *San Joaquin Historian* 14, no. 3 (Fall 2000): 3.

Costa, Connie S. "A Place of Their Own: The Nippon Hospital." In *Stockton: A Glance into the Past.* uop.edu/cop/jacobycenter/projects/Stockton%20Historical/agtp_e02.html.

Mabalon, Dawn B. *Little Manila Is in the Heart: The Making of the Filipina/o American Community in Stockton, California.* Durham, NC: Duke University Press, 2013, 1–7.

———. "Losing Little Manila: Race and Redevelopment in Filipina/o Stockton, California." In *Positively No Filipinos Allowed: Building Communities and Discourse*, by Antonio T. Tiongson Jr., Edgardo V. Gutierrez and Ricardo V. Gutierrez. Philadelphia: Temple University Press, 2006, 76.

Mabalon, Dawn B., Rico Reyes, the Stockton Chapter, Filipino American National Historical Society and the Little Manila Foundation. *Filipinos in Stockton.* San Francisco: Arcadia Publishing, 2008, 8.

Stockton Record. "Stockton Writer Traces the Mostly Forgotten History and Noble Filipino Heritage of the Little Manila District in New Book." July 12, 2013.

Chapter 20: Beverly Fitch McCarthy

Darrah, Joan. *Getting Political: Stories of a Woman Mayor.* Sanger, CA: Quill Driver Books, 2003, 129.

McCarthy, Beverly Fitch, in conversation with the author, October 17, 2013.

Veteran Feminists of America. www.vfa.us.

Index

About the Author

Mary Jo Gohlke is a retired librarian. She provided reference services and adult programming for the Stockton–San Joaquin County Public Library System for eight years. Previously, she has been a news writer and editor in the Bay Area and Eureka. She and her husband, Rich, reside in Stockton and have two children and two grandchildren.